Stephanie Brown

RELIGIOUS PAINTING

MAYFLOWER BOOKS
NEW YORK

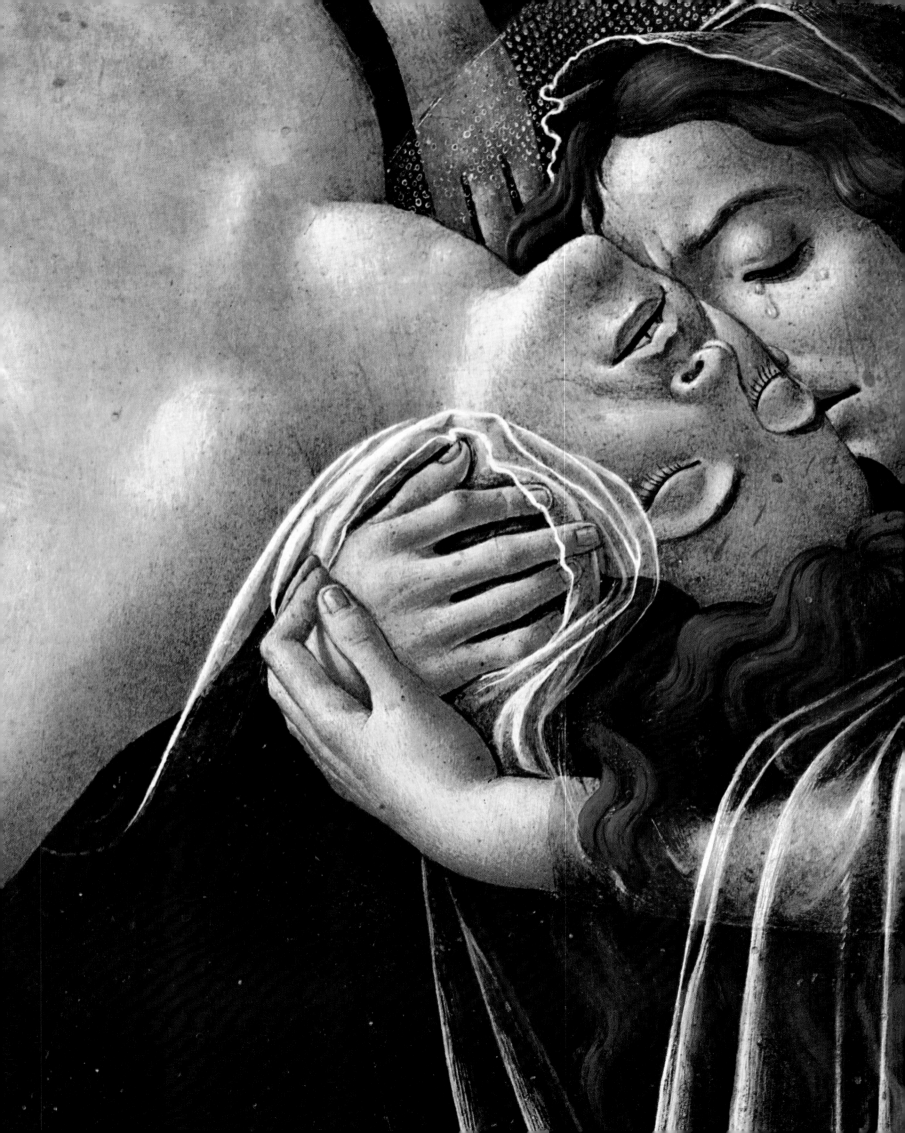

Stephanie Brown

RELIGIOUS PAINTING

CHRIST'S PASSION AND CRUCIFIXION

OVERLEAF **Botticelli**: *Pietà* (detail)

MAYFLOWER BOOKS, INC.,
575 Lexington Avenue, New York City 10022.

© 1979 by Phaidon Press

All rights reserved under International and Pan
American Copyright Convention.
Published in the United States by Mayflower Books,
Inc., New York City 10022.
Originally published in England by Phaidon Press,
Oxford.

Library of Congress Cataloging in Publication Data

 BROWN, STEPHANIE.
 Religious painting.

 1. Jesus Christ – Passion – Art. 2. Jesus
Christ – Crucifixion – Art. 3. Painting, Medieval.
4. Painting, Renaissance. 5. Painting, Baroque.
I. Title.
ND1430.B76 755'.4 78–24454
ISBN 0–8317–7370–7
ISBN 0–8317–7371–5 pbk.

Filmset in England by SOUTHERN POSITIVES AND NEGATIVES
(SPAN), *Lingfield, Surrey*
Manufactured in Spain by HERACLIO FOURNIER SA, *Vitoria.*
First American edition

THE SEQUENCE OF EPISODES from the life of Christ, known collectively as the Passion, and which spans the last events of his earthly existence from the Entry into Jerusalem to the Entombment, occupies a position of central importance in religious art. Whether incorporated into extended cycles depicting the life of Christ, presented as an independent series, or treated as individual subjects, these episodes are primarily concerned with Christ's human suffering, degradation, and death. As such, the relative frequency or rarity of the depiction of these episodes during different periods, is extremely informative about the prevailing spiritual, ethical, and aesthetic conditions.

When the Passion is presented as an independent cycle the number of episodes incorporated into it may vary considerably. Most extended cycles commence with the Entry into Jerusalem and close with the Entombment although some begin at a later point and others may terminate with the Resurrection. The number of episodes in any given cycle would be influenced by the medium, such as fresco, altarpiece, panel, or canvas, by the intended location of the work, and by the particular requirements of the commissioning body. Whatever the number of episodes, the central event is almost invariably the Crucifixion, and it is this episode which is most frequently detached and presented as a separate subject. The Crucifixion epitomizes the particular character of the Passion, presenting the cumulative effects of Christ's physical suffering, in addition to its significance as the source of the universal and economical symbol of Christianity and the keystone of its redemptive ethos.

If the Crucifixion is the pivotal episode of the Passion and the image that is most familiar, it was by no means central to the earliest Christian art. The simple emblematic imagery of the early Christians functioned as a reinforcement of faith and concentrated on Christ's deific qualities. The Crucifixion

Joos van Cleve: *Crucifixion Triptych*, central panel 91 × 51cm, side panels 90 × 27cm, c.1520

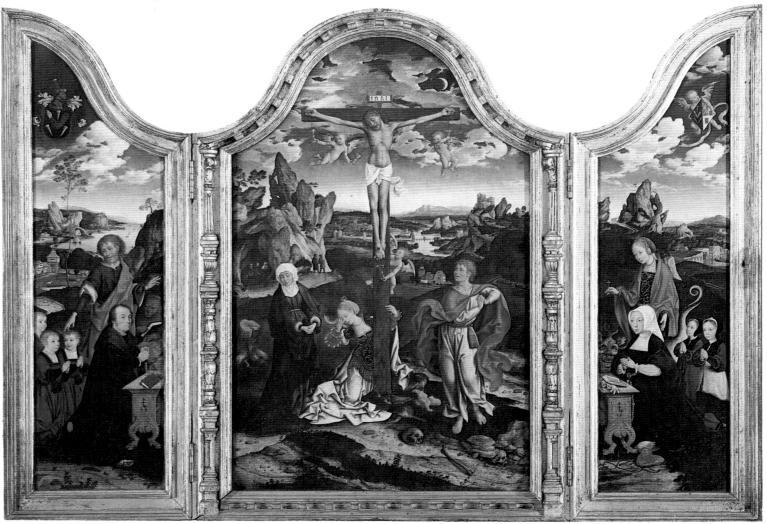

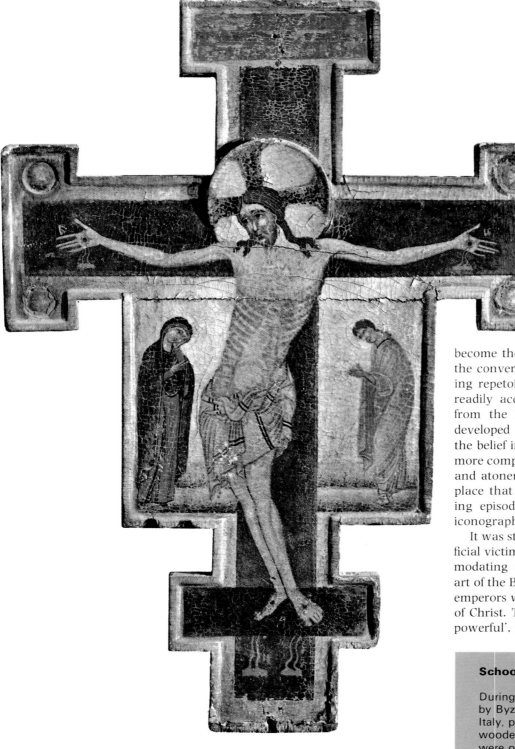

become the official religion of the Roman Empire following the conversion of the Emperor Constantine IV, the expanding repetoire of images depicting the life of Christ did not readily accommodate the painful and degrading episodes from the Passion. At this time Christians had not yet developed the sense of sin and guilt that was to replace the belief in salvation, secured through pure faith, with the more complex idea of redemption, gained through penitence and atonement for sin. It was only when this change took place that the Crucifixion and the less immediately uplifting episodes of the Passion became central to Christian iconography.

It was still faith in a powerful deity, rather than in a sacrificial victim reduced to suffering flesh for the sake of accommodating man's sin that motivated the brilliant mystical art of the Byzantine period. The type of image used to glorify emperors was easily adapted into an equivalent glorification of Christ. The triumphant image of Christ Pantocrator, 'all powerful', the spiritual coequal of supreme Imperial power,

School of Pisa: *Crucifix,* 104 × 74cm, 13th century

During the thirteenth century painted crosses, inspired by Byzantine models, became widespread in central Italy, particularly in Pisa. The Pisan crucifix was a wooden version of the Byzantine reliquaries, which were opulent crosses of gold or silver with relics contained in small decorative receptacles at the lateral extremities. These reliquaries influenced the form of the Pisan crucifix with its box-like extensions and decorative motifs. For economic reasons, wood was used instead of precious metals, but, although less elegant than the Byzantine prototype, these painted crosses promoted new aesthetic developments and a wider dissemination of images. To accommodate the image of Christ's body, wooden crucifixes required increased width in the upright section, and these central panels and the rectangular extensions, were embellished with standing figures, usually of St John and the Virgin. This cross, painted in the first half of the thirteenth century, shows the Byzantine type of Christ as 'Triumphant Pantocrator' with open eyes.

not only presented Christ as a vulnerable and suffering mortal but was also fraught with ambiguity for those who could still feel threatened by a particularly shameful and agonizing form of execution. When subjects from the Passion began to be represented they were positive affirmations of faith such as the triumphal Entry into Jerusalem, the miraculous Resurrection, or the Descent into Limbo with its message of the victory of life over death. These subjects were also more likely to make converts than the horrors of the Flagellation or the Crucifixion. When Christ's death was alluded to, it was symbolically, through references to Old Testament parallels, the sacrifice of Isaac or the death of Abel. The Crucifixion itself does not appear earlier than the fifth century and is relatively infrequent until the tenth.

During the triumphant phase of Christianity, after it had

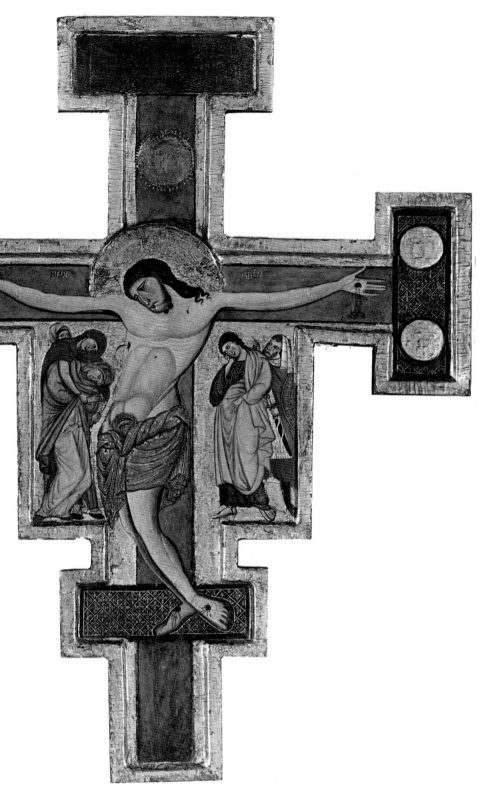

Master of St Francis: *Crucifix*, 92 × 70cm, c.1272

dominated the apse in the Byzantine church. The insistence upon Christ's human vulnerability, which is essential to the episodes of the Passion cycle, had no place within an iconography based on divine invincibility.

When the cross was depicted in conjunction with the image of Christ in glory, it was shown as a symbol of salvation, a positive attribute of Christ, rather than as an allusion to his physical suffering. It was not until the tenth century that the image of Christ shown actually hanging upon the cross became more frequent. Even so, in this early form it was still far removed from the archetype of the pained and passive figure central to the Passion cycle. The Byzantine prototype of Christus Triumphans, a Christ shown alive on the cross, the body upright and the eyes open, is common in the eleventh and twelfth centuries and this form is continued in the painted crosses of the School of Pisa during the first half of the thirteenth century. This is still an essentially triumphant image, which in many respects combines the basic elements of both the Crucifixion and the Resurrection. It continues to present an awe-inspiring God, a phoenix-like figure, the survivor of a death that mobilized supernatural forces, extinguished the sun, and convulsed the earth.

The transition from this rigid form to one that becomes progressively pendent and contorted with pain is seen in crosses made in Pisa of the second half of the thirteenth century. However, from the eleventh century this image of Christus Patiens, hanging dead on the cross, the head inclined and the eyes closed, had gradually been replacing the idea of the Word incarnate with a new concept of human pathos. It was the replacement of a remote and powerful deity with a human, suffering Christ that constituted the first stage in the evolution of the Passion cycle, as a narrative depending upon an unequivocal acceptance of suffering and mortality. Scenes of crosses and crucifixes often included the figures of St John and the Virgin on either side of Christ, but, increasingly, episodes from the Passion occupied the panels flanking the cross.

Medieval art reflected the growing emphasis on the horror of sin which was thought to 'wound the feelings' of Christ. The progressive exaggeration of the degree of suffering shown in depictions of the Crucifixion was not necessarily an attempt at the realistic rendering of the agonies of crucifixion. Such exaggeration served equally to emphasize the 'wounding' of Christ caused by man's sin. A similar doctrinal significance was attached to the frequently excessive quantities of blood shown spurting from the wounds in the hands, feet, and side of Christ. The axiomatic belief that Christ's blood could cleanse man of sin was in fact stressed by a seeming superfluity of blood in paintings of the Crucifixion. When haemorrhagic amounts of blood are combined with a realistic and detailed description of physical torment, as often

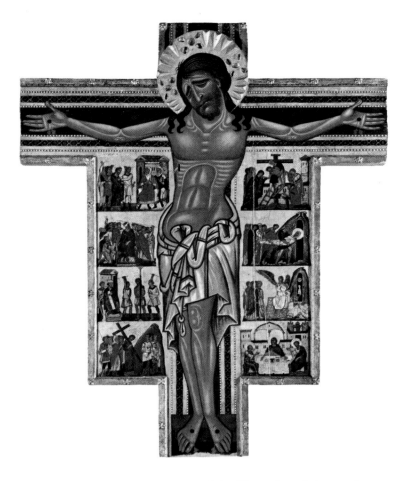

During the thirteenth century the figure writhing in pain on the cross completely eclipsed the composed and passionless figure based on the Byzantine convention. An innovation, resisted for some time, was the depiction of one nail instead of two, transfixing the feet so that the legs were crossed, one knee bent, and the painful contortion rendered more realistic.

The pathos now embodied by the Crucifixion extended itself to the other episodes of the Passion where there was an increasing emphasis on the more painful events. The Passion cycle began to develop as a separate series rather than being incorporated into extended cycles of the life of Christ or being represented in panels surrounding painted crucifixes. The most important influence in this major development was the impact of Franciscan and Dominican preachers, with their exhortations to contemplate Christ's sufferings during the Passion. This influence, which originated during the thirteenth century, led to the proliferation of the Passion cycle.

The earliest Passion cycles, in common with the Nativity and Parables cycles and the composite cycles of the life of Christ, were concerned neither with illusionism nor innovation, and were primarily pedagogical in intention. They showed slight concern with the type of historical accuracy that would have obscured and detracted from their didactic aim. It is only in the early fourteenth century with Duccio's great Maestà altarpiece cycle, at the Museo dell'Opera del Duomo, Siena, that the Passion cycle begins to show a more sophisticated pictorial approach and a historical dimension that transcends the merely didactic. Duccio's comprehensive cycle painted between 1308 and 1311, establishes the widest range of episodes that may be deduced from the basic description of the events of the Passion given in the Gospels.

Franciscan and Dominican influence not only led to an increase in painted Passion cycles but also prompted a pre-occupation with the Passion in dramatic expression. The mystery dramas, the French *Mystères*, the *Sacre Rappresentazioni* of Italy, and the *Geitspiele* of the Germanic countries,

occurs in German painting of the fifteenth and sixteenth centuries, the doctrinal significance is diminished. Instead of its earlier significance as a symbol of redemption, such excess served to intensify horror and a sense of culpability which would make redemption a proportionately difficult prospect. A similar diminishing of doctrinal import is seen in Italian painting of the same period when Renaissance idealism often resulted in a total absence of signs of bleeding.

The attitude that gave rise to an increasing emphasis on Christ's physical suffering in paintings of the Crucifixion is epitomized by a letter from Abélard to Héloise. Written after the termination of their physical relationship and designed to divert Héloise's devotion from himself to Christ, Abélard's letter recommends a pious contemplation of the Passion:

> *Dearest sister, are you not moved to compunction by the sight of the only begotten of God, who although he was innocent, yet for you and for all men was taken by the impious, was scourged, mocked, spat upon, crowned with thorns and executed between thieves by so frightful and shameful a death? Look upon him, your bridegroom and the bridegroom of the Church.*

Abélard was writing during the first half of the twelfth century and his words amply demonstrate the degree to which an object of human pathos had replaced an awesome deity. As emblematic representations of the Crucifixion gradually gave way to an increasing anthropomorphism there was a growing tendency to show the Crucifixion as an actual event rather than an amplified symbol. In recommending meditation upon the Passion, Abélard stresses the significance of the Crucifixion as the final event in a series of indignities.

School of Pisa: *Crucifix with Episodes from the Passion*, 277 × 231 cm, and detail, second half of 13th century

This crucifix is typical of those produced in Pisa during the second half of the thirteenth century and shows the impact of Franciscan ideas. The particular influence of these ideas was that the impassive, triumphant figure of Christ was replaced by the dead Christ, eyes closed, and face expressive of suffering. Apart from the head, the figure on this painted cross is highly stylized and essentially Byzantine in manner. Instead of the figures of the Virgin and St John occupying the widened side sections, this cross shows the alternative convention of incorporating narrative compartments depicting episodes from the Passion. The episodes conceived as simple pictographs are Christ Condemned to Death, the Mocking of Christ, the Flagellation, Christ Carrying the Cross, the Deposition, the Entombment, the Three Maries at the Sepulchre, and the Supper at Emmaus.

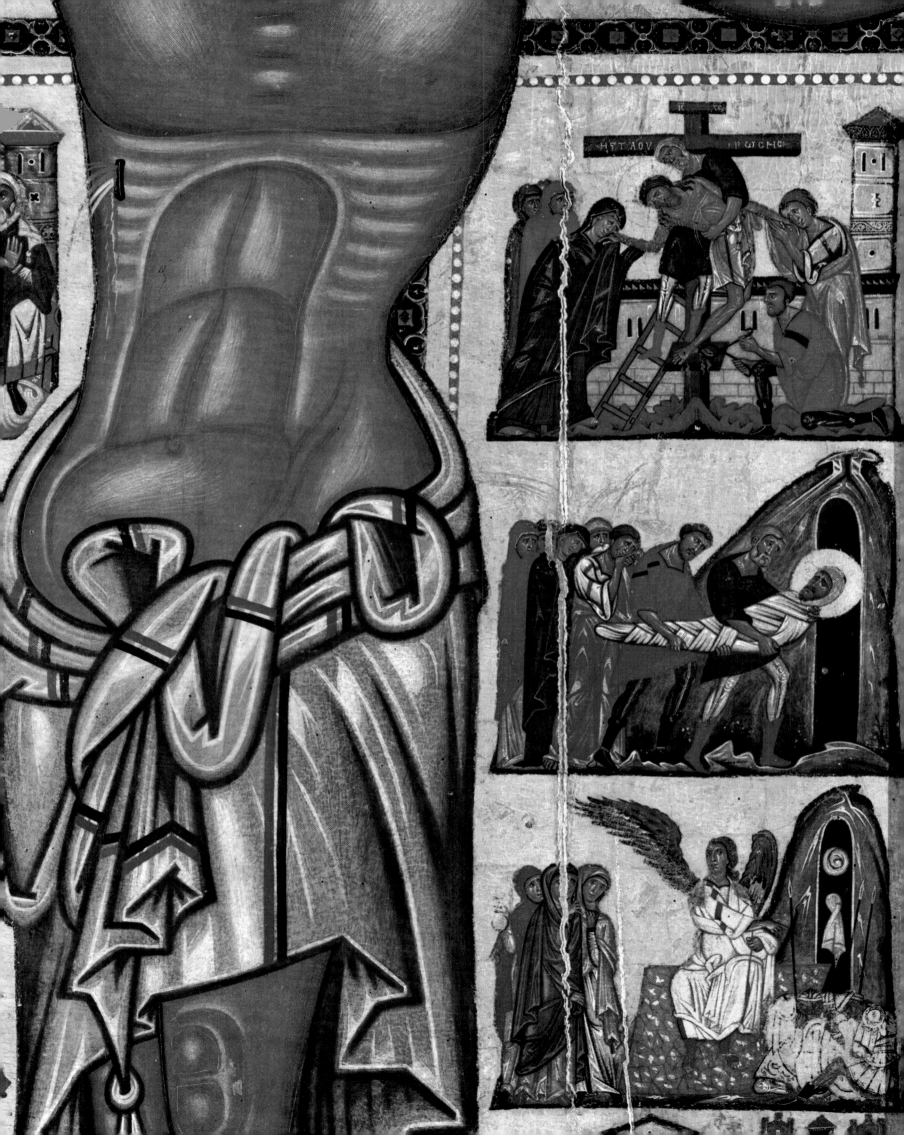

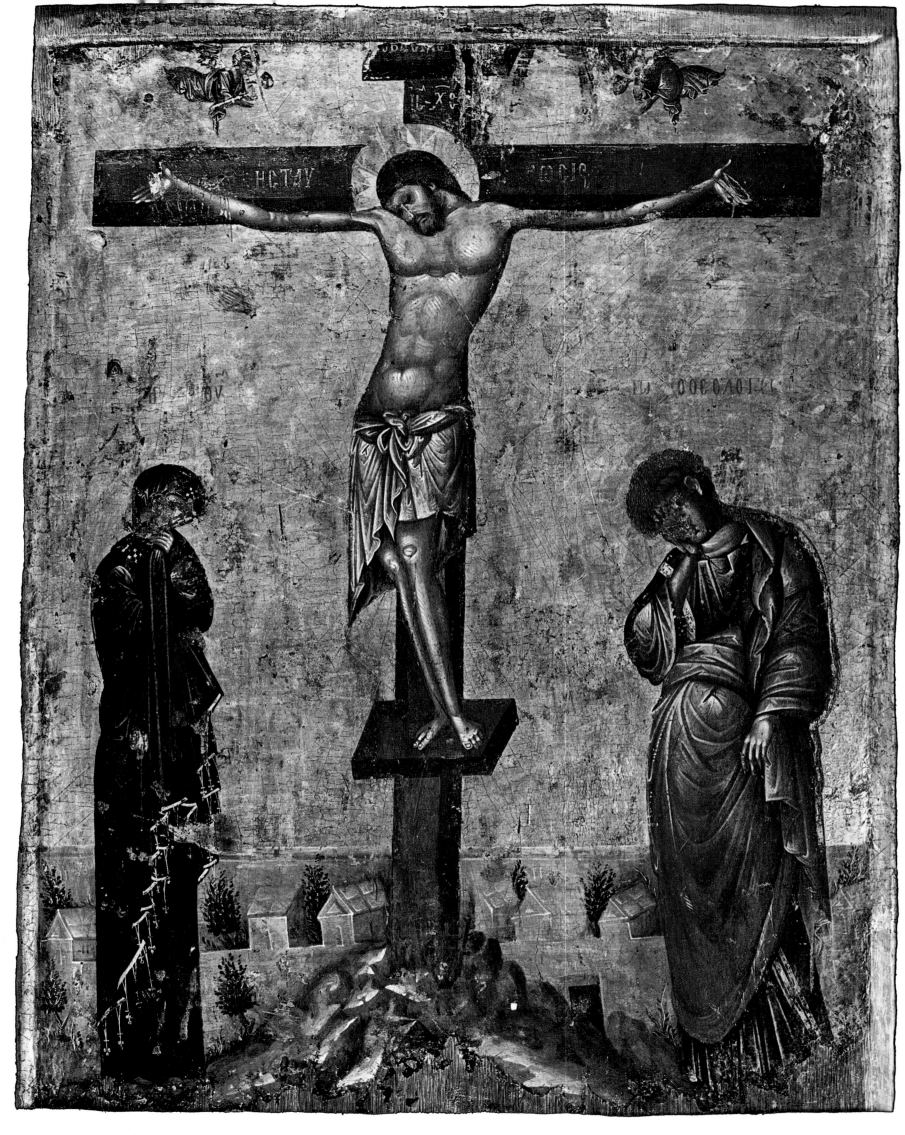

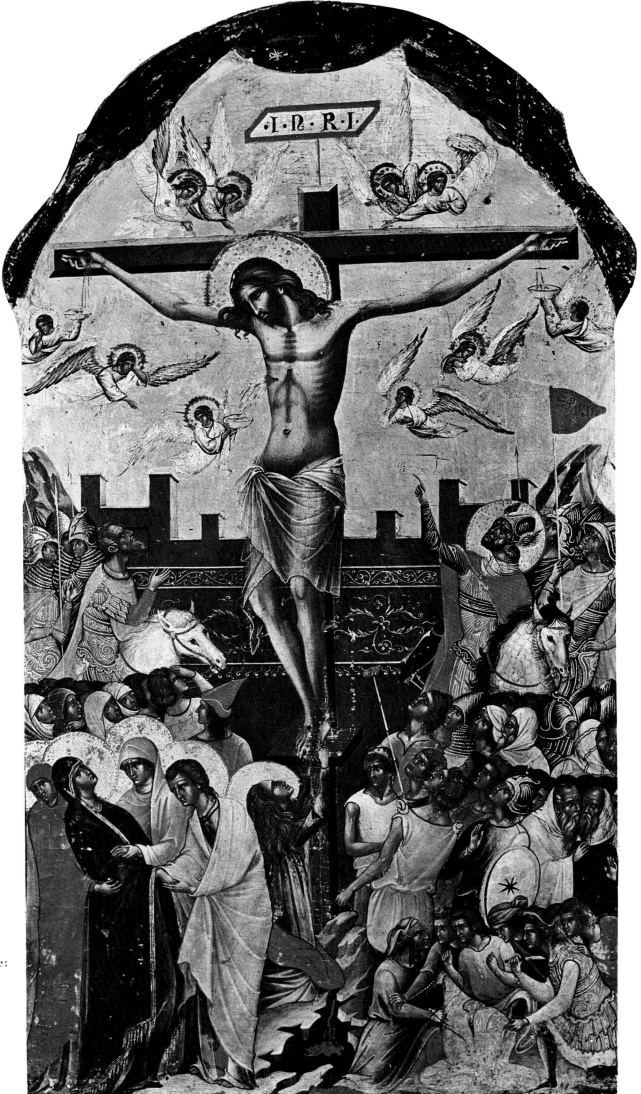

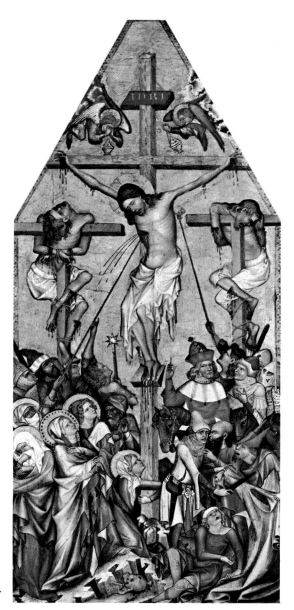

Master of Bohemia:
Christ between the Two Thieves.
c.1350 67 × 29.5cm.

in visionary descriptions of the details of Christ's physical agonies. The most influential of these were the *Meditations* ascribed to the Franciscan, St Bonaventura, and the *Revelations* of St Bridget of Sweden. St Bridget's *Revelations*, in particular, had a profound effect upon depictions of the Passion, most notably during the fifteenth and sixteenth centuries. They were to influence the work of artists as diverse as Roger van der Weyden, Dürer, Antonello da Messina, El Greco, and, most dramatically, Grünewald. St Bridget experienced remarkable visions from an early age, including a particularly vivid one of the Crucifixion; she did not die until 1373, having witnessed the ravaging of Europe by the bubonic plague which lasted from 1347 to 1351. The particularly gruesome and macabre character of her visions is in keeping with the exaggerated emotionalism, psychological morbidity and extreme mysticism that was generated by the decimation of a quarter of Europe's population by the Black Death.

A familiarity with genuine horror, the eschatological preoccupations of the time, the *Ars Moriendi*, and the tombs, embellished with skeletons and maggot-infested corpses, all served to invest the Passion cycle with a new significance. Those who were conditioned by the experience of real death and disaster needed the stimulus of the extreme to trigger off tearful piety, guilt, and penitence. Consequently, in Italian provincial art, and more specifically in the art of the Northern countries, there was an increasing preoccupation with the more harrowing episodes of the Passion. In German art particularly, the Flagellation, Crowning with Thorns, Crucifixion, and Lamentation were the episodes most likely to be treated with an extreme and morbid realism, designed to provoke a chain reaction of horror, pity, guilt, and atonement which, with luck, would secure redemption. The Passion had a particularly important role to play in inspiring the piety and penitence that was necessary to save the soul from Hell. This disagreeable resort was frequently depicted, and paintings such as the *Last Judgement* by Hubert van Eyck and that by Bosch, vividly portrayed the torments of the lost soul prodded by demons with pitchforks, abused, and

School of Bohemia:
The Man of Sorrows.
31 × 20cm

exerted a strong influence on the imagery of the Passion in painting. The importance of the Passion cycle was also aligned to the formal ritual of the Church liturgy of Holy Week when the events of the Passion were ceremonially re-enacted.

It was not only the seminal Gospel accounts and the dramas that influenced the imagery of the Passion paintings. An increasing importance can be given to the writings of mystics whose particular devotion to the Passion resulted

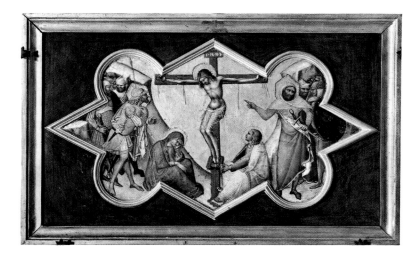

Lorenzo Monaco:
Crucifixion.
32·5 × 56·5cm

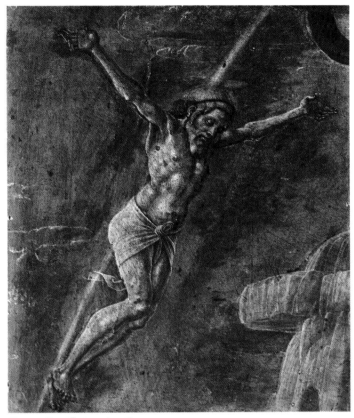

Tura: *Crucifixion* (detail)

relatively anodyne and idealized to a degree that precludes an excessively emotional response.

If little emphasis on cruelty and suffering is discernible in Italian paintings of the Passion, it is a salient characteristic in the Germanic equivalents, and one that was exacerbated by the Reformation. The Crucifixion held a position of central importance in Luther's beliefs, and because of his disapproval of certain more specifically Catholic subjects such as the Life of the Virgin cycle, the *sacra conversazione*, and subjects pertaining to miracles, the Passion provided the major themes of the religious painting of the Reformation. Apart from the Crucifixion, the episodes most frequently depicted were the Flagellation, Mocking, Crowning with Thorns, and Deposition of Christ. These subjects allowed the exercise of that aggressive obsession that resulted in Christ being shown as the victim of startlingly ingenious and sadistic indignities, his tormentors reduced to ferocious caricatures, and his body to a mutilated corpse, to be disposed of as rapidly as possible.

If the effect of the Reformation was to lead to the proliferation of certain episodes from the Passion, the general effect of the Counter-Reformation was to diminish the importance of subjects from the cycle. The Council of Trent, which opened in 1545 and held its final session in 1563, was called in

Antonello da Messina: *Christ Supported by an Angel.* 74 × 61cm

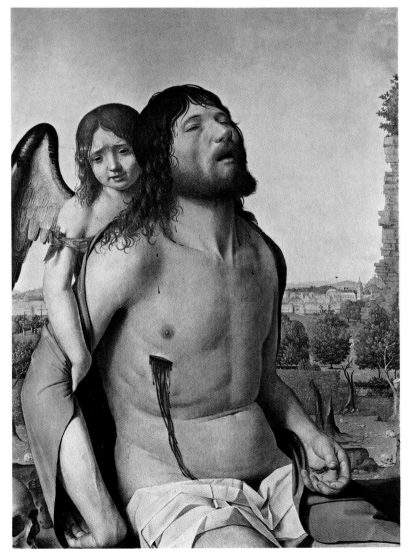

obscenely violated. Such images made the idea of redemption even more acceptable, and in contemplating paintings of Christ undergoing the agonies and outrages of the Passion, the spectator could endeavour to avert a similar post-mortem fate through experiencing a very human empathy with the victim.

If Northern painting of the fifteenth and sixteenth centuries progressively depicted the episodes of the Passion as convulsed and gruesome atrocities, Italian painting of the same period tended to show them as serene and monumental. Although the humanism and secularism of the Renaissance, with its interest in Classical pagan myth, coexisted with a continuing faith in Christianity, they nevertheless rendered this faith comparatively restrained and rationalist. There was little sign of pathos, and even less of paroxysm, in paintings that obeyed the classical precepts of decorum, moderation, and idealism and that subjected the episodes of the Passion to the dictates of reason. In many cases there is evidence of a new insight into the Passion as a psychological drama, and on the whole, attention to historical accuracy surpasses any involvement with detailing the external indications of suffering.

Extended Passion cycles were comparatively rare in the art of the Italian Renaissance, and the dwindling of didactic purpose in individual easel paintings tended to result in idiosyncratic interpretations. Historical authenticity, proliferation of detail, and a widening of iconography in the treatment of episodes from the Passion, resulted in a gradual submersion of the simpler doctrinal details. In comparison with Northern paintings of the same period, the effect of even the most painful episodes, the Flagellation or Crucifixion, is

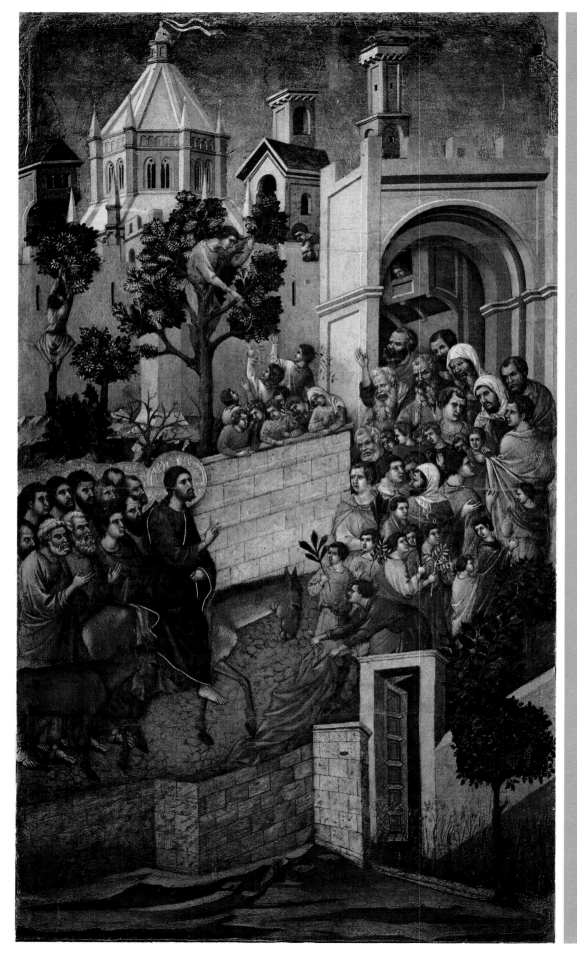

Duccio: *Entry into Jerusalem*, 1308–11

This panel, the first in Duccio's *Maestà* cycle, is probably the masterpiece of the whole series. Although this *Entry* incorporates all of the traditional elements of the subject, it departs from earlier conceptions by setting Christ comparatively far back on the picture plane and establishing a new kind of spatial depth. The main occupation of the medieval artist was to translate the Gospels into coherent, narrative images readily intelligible to the illiterate. Scenes from Duccio's cycle, such as the *Entry*, retain clarity but introduce an innovatory amplitude and subtlety, which transforms the functional, didactic image into a more animated and independent scheme. Duccio also departed from Byzantine convention by introducing a greater variety and intensity of emotion. This increased sense of humanity was directly due to Franciscan and Dominican influence.

order to organize a defence against the Reformation and re-state the basic tenets of Catholicism. The final session of 1563 established certain rules that were to govern the arts. In relation to religious subjects, nudity and useless embellishment were censored, along with works that appeared to perpetuate erroneous dogmas, aprocryphal details, and elements that deviated from an exact interpretation of the Gospels. These proscriptions had a particular effect on the subjects from the Passion, which had tended to accrue legendary elements to reinforce the basic Gospel accounts. In addition, there was a proliferation of those subjects that had come under a heavy attack from the Reform churches, the cult of the Virgin and of various saints, miracles, mysticism, martyrs, and ecstatics. Paintings of the Immaculate Conception and subjects from the Life of the Virgin took over from the episodes of the Passion. The Passion tended to become little more than a source for devotional paintings of the Crucifixion, the Ecce Homo, and the Man of Sorrows.

Although many of the directives of the Council of Trent were directed against Protestant realism with its individualistic tendencies, they also opposed the more austere individualism, intellectualism, and idealization of the Renaissance. In many respects, interpretation of Counter-Reformation requirements was not opposed to the theories of the Reformation. In his *Treatise on Ethical, Human, and Fabulous Poetry and Painting*, written under the influence of the Council of Trent and published in 1593, Antonio Possevino reinforces a concept of uncompromising rigour in relation to the scenes of the Passion: 'It was God's wish that his Son, Jesus, should be degraded for our sins, bleeding, torn, covered with whip lashes and spittle, bruised and prostrate with blows.' This insistence upon Christ's appearance as a mutilated and humiliated victim can be partly explained as an expression of the reaction against the classicizing idealism of the Renaissance. This is nevertheless tempered by Possevino's recommendation that the antique statue of Laocoön could serve as a paradigm for the suffering Christ. Possevino's words describing the stark realities of Christ's ordeal show striking similarities with those used by Abélard almost five centuries earlier. However, the spiritual and aesthetic climate of the seventeenth century was not receptive to scenes of cruel realism, and the sensuous and tumultuous dramas of the Baroque proved an uneasy vehicle for the episodes of the Passion. From the seventeenth century Church commissions for Passion cycles and episodes from the Passion other than the Crucifixion, decreased significantly. The great narrative cycle of the Passion survived mainly in the reduced form of the Stations of the Cross, the stereotyped bas-reliefs or painted panels, which have been an invariable presence in Catholic churches since the sixteenth century.

The Stations of the Cross comprise only fourteen episodes, and although Passion cycles varied considerably in the number of episodes depicted, Duccio's *Maestà* cycle, consisting of twenty-six episodes, established what was probably the widest range of subjects that could be derived from the basic Gospel accounts. In considering those episodes from the Passion that could be selected to form a sequence, or that were the basis for individual compositions, the range of episodes established by Duccio provides the most comprehensive coverage. Duccio's cycle consists of the following episodes: the Entry into Jerusalem, Christ Washing the Disciples' Feet, the Last Supper, Christ's Last Address to the Disciples, the Pact of Judas, the Agony in the Garden, the Arrest of Christ, the Denial of Peter, Christ before Annas, Christ before Caiaphas, the Mocking of Christ, Christ before Pilate, Pilate Addresses the Crowd, Christ before Herod, Christ again before Pilate, the Crowning with Thorns, Pilate Washing his Hands, the Flagellation, the Road to Calvary, the Crucifixion, the Descent from Cross, the Entombment, the Descent into Limbo, the Three Maries at Sepulchre, Christ Appears to Mary Magdalene, the Supper at Emmaus.

The Entry into Jerusalem is almost invariably the first episode of extended Passion cycles and shows Christ's joyful reception into the city, which, only a few days later, he would leave on his way to execution. Being triumphant in character, the subject appeared most frequently in the earlier cycles and had been one of the episodes depicted on the sarcophagi of the catacombs, where the imagery tended to derive from traditional Roman representations of the triumphal entry of an emperor into a city. The Gospels recount that Christ entered the city riding on an ass, that the disciples had spread their garments on its back, and that he was met by a crowd who threw down palm branches and garments in his path. Although very early depictions are often limited to Christ on the ass, one or two disciples, a figure laying down a garment, and another in the branches of a token palm tree, the picturesque potential of the subject was increasingly exploited.

Giotto's *Entry* from the fresco cycle in the Scrovegni Chapel (1303–5) includes all the traditional elements of the

School of Central Greece: *Entry into Jerusalem.* 39 × 31cm. 16th–17th century

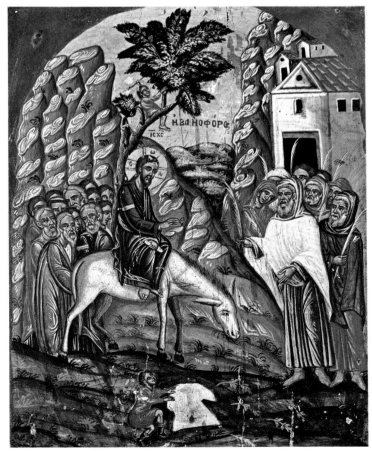

scene; Christ is placed in the centre of the composition and viewed in right profile so that his right hand, raised in blessing, can be clearly seen. The fresco shows the common figure of the man looking on the event from a tree. This single figure is generally interpreted as representing the publican, Zacchaeus, who was small of stature and climbed into a tree to get a better view. The incident is recorded by Luke who describes it as taking place in Jericho on Christ's way to Jerusalem. This anachronism originated in early interpretations where consecutive incidents were frequently compressed into a single composition. Later versions multiply the number of figures climbing trees to secure a better vantage point or to cut down palms, and, consequently, while the reference to Zacchaeus is lost, the animation of the scene increased. Increased animation and a new pictorial

sophistication characterize Duccio's *Entry*, which was painted shortly after Giotto's more economical and traditional composition.

The Entry into Jerusalem is seldom seen after the fourteenth century and scarcely appears at all in German and Flemish painting. A further rarity in Passion cycles of any period is the dramatic event that all four Evangelists describe as having immediately followed the Entry, either later on the same day, or on the following day. This was Christ expelling the Money-Changers from the Temple, an episode which is not treated by Duccio, and which, in spite of its position as the reported sequel to the Entry, is seldom incorporated into Passion cycles. However, it does appear as an individual subject, particularly during the sixteenth and seventeenth centuries. It is not difficult to account for this

Tintoretto: *Christ Washing the Disciples' Feet.* 210 × 533cm. c.1547

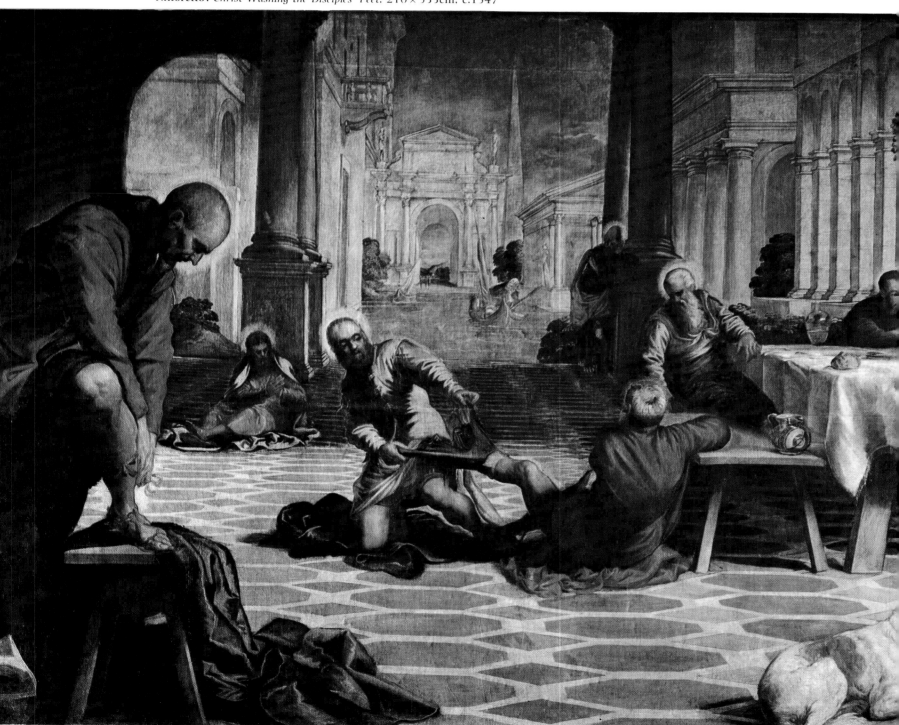

avoidance of a key event in the Passion narrative. On visiting the Temple, Christ was overcome with anger and indignation at the profiteering activities of merchants and money changers. In a forceful exhibition of moral authority, he overturned their tables and drove them from the Temple. This was in fact the final provocation that prompted the chief priests and scribes into deciding upon his destruction, and, as such, is a pivotal episode in the succeeding events of the Passion. Nevertheless, a display of anger and violence is incompatible with the humility and resignation that characterizes Christ's behaviour throughout the Passion, and would appear incongruous in the cycle as a whole.

An episode that depends entirely on Christ's humility is the Washing of the Disciples' Feet, which immediately precedes the Last Supper. Although John is the only one to mention this incident, it is frequently depicted in Passion cycles and there are notable examples by Duccio, Giotto, Fra Angelico, and Tintoretto. The episode is essentially didactic, setting an example of humility and self-effacement, and most versions show Christ kneeling to wash Peter's feet, with the disciple reacting with a gesture of protest or dismay. Although Christ is usually shown in the centre of the composition, Tintoretto's painting places him to the extreme right and breaks away from classical tradition by the Baroque exploitation of movement and spatial depth. Two thirds of the composition is occupied by the disciples pulling off their hose or sitting around the table awaiting their turn. Only Peter and the disciple holding the pitcher pay any attention to Christ, and the viewer's eye also tends to ignore him as it is drawn into the depth of the picture by the striking perspec-

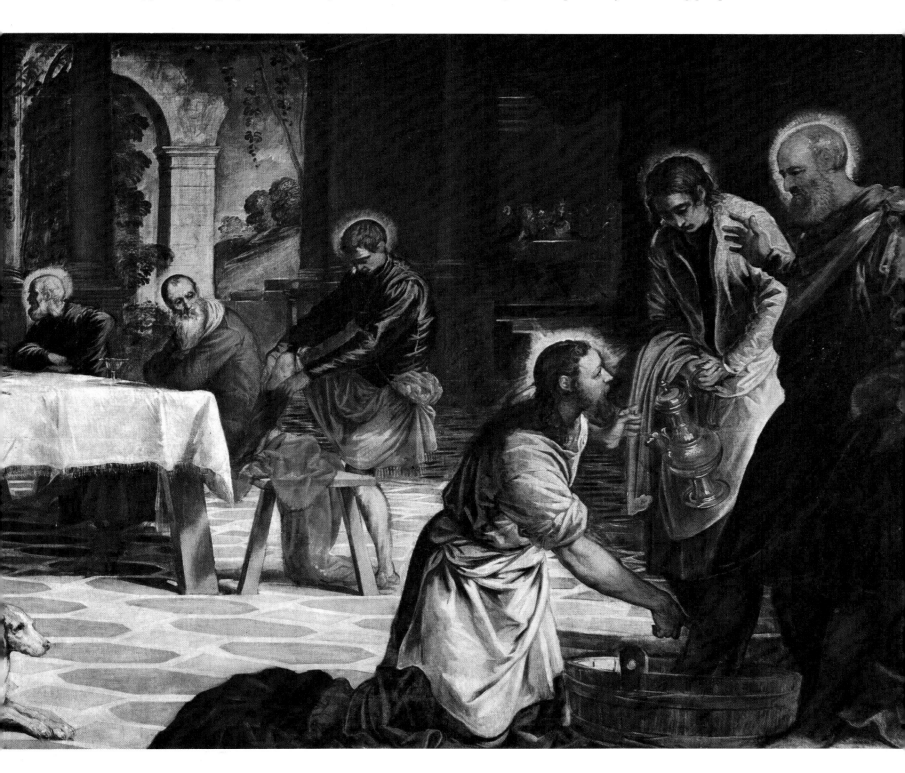

tive of the elaborate chamber, which opens out into the lagoon beyond. Tintoretto here demonstrates the sumptuous and sophisticated effects that characterize much of the painting of the Counter Reformation.

The Last Supper is a major episode in the Passion consisting of two distinct narrative and doctrinal incidents, Christ's prediction of his betrayal by Judas, and his institution of the

Leonardo: *Last Supper*, 1497

Painted for the refectory at the monastery of Santa Maria delle Grazie, Leonardo's *Last Supper* is rightly considered to be the most perfect rendition of the subject. Reduced almost to a phantom of a painting through deterioration and damage, the brilliance of the conception is, nevertheless, as clear as ever. Christ has just spoken, revealing that he knows both of his imminent betrayal and the identity of the betrayer. The disciples react, each gesture and expression conveying a nuance of emotion and a well-defined character. Protestations of innocence, incredulity, consternation, and questioning disrupt the serenity of the gathering, while uniting the disciples into four groups of three figures, each group harmoniously linked with the next by some connecting action. In the midst of this agitation and psychological upheaval, the eye returns inevitably to the static central point of the composition, the calm and saddened figure of Christ. One of the most perceptive accounts of the drama of this painting is given in Goethe's essay *Observations on Leonardo da Vinci's Celebrated Picture of the Last Supper* (1817).

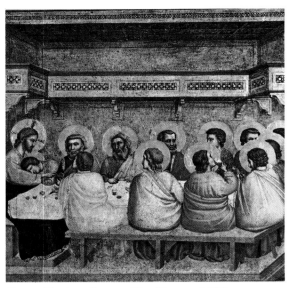

Giotto: *The Last Supper*, 42 × 43 cm, c. 1320

Eucharist, the most important Christian sacrament. Both of these aspects involved difficulties in depiction because both required the presence of thirteen very similar figures seated around a table, with only one attracting an important degree of attention and the others tending to be reduced to the cumbersome role of interested onlookers. This disadvantage was particularly evident in the scene of Eucharist where Christ is shown raising his hand to bless the bread and wine, a moment of solemnity and grace, but one that leaves the Apostles with little scope for significant action or reaction.

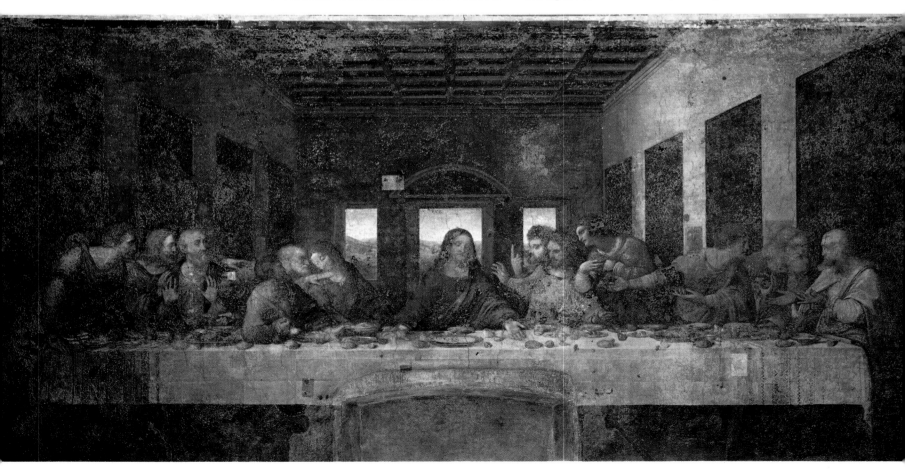

Although this distinct pictorial handicap partly explains why the Eucharistic interpretation of the subject is seldom incorporated into Passion cycles, there are further, more specific, reasons. Not only does the moment when Christ reveals that his betrayer is in their midst provide the Apostles with the opportunity for dramatic reaction, but it also establishes a greater continuity with the succeeding episodes of the narrative. In addition to this, the solemnity and significance of the institution of a major sacrament was probably considered by the Church as warranting a separate treatment for the subject rather than being fitted into a narrative cycle. Tintoretto's *Last Supper* painted in 1593 epitomizes the Counter Reformation emphasis on the depiction of the sacraments, and actually shows Christ giving the Host to one of the Apostles. The composition differs radically from the convention of showing the table parallel with the picture plane, usually with Christ in the centre, and the scene is presented from an extreme diagonal angle. This device diminishes the figure of Christ through the dramatic perspective so that he is smaller than the foreground figures.

If Tintoretto's composition departs from the traditional presentation of the scene, Leonardo's amplifies the conventional square-on viewpoint and invests the subject with a unique psychological dimension. Leonardo's *Last Supper* depicts the moment when Christ speaks the words: 'But, behold, the hand of him that betrayeth me is with me on the table' (Luke 22:21). This was the moment in the Last Supper that was most commonly depicted, and Giotto's painting establishes the very static, conventional treatment of the subject, showing the Apostles isolated from one another, both spacially and emotionally. This convention is seen in the later versions by Andrea del Castagno and by Ghirlandaio but with Leonardo, the figures are no longer rendered as essentially separate entities. Instead they are rhythmically linked by physical and emotional interaction. The Last Supper was often executed as a decorative painting for the refectories of monasteries and convents.

In Duccio's cycle this episode is followed by *Christ's Last Address to his Disciples* and the *Pact of Judas*. Neither of these subjects were common either as part of a series or as individual paintings. They had little to distinguish them pictorially, and although Christ's Address possessed a didactic significance this was entirely absent from the Pact of Judas. In most cycles the Last Supper is followed immediately by the Agony in the Garden, which is the introduction to the Passion proper in the sense of Christ's ordeal of persecution and suffering. This subject was seldom depicted before the thirteenth century, but because of the influence of Franciscan preachers with their exhortations to contemplate the sufferings of Christ, it became a major episode in the cycle and was frequently treated as an independent subject.

The Gospels of Matthew, Mark, and Luke recount that after the Last Supper Christ went to pray in the garden of Gethsemane on the Mount of Olives. He was accompanied by eleven disciples (Judas having gone off to inform on his whereabouts), and appointing Peter, John, and James to keep watch, he withdrew to commune with God. The watch promptly went to sleep, and, almost without exception, paintings of the Agony show the three sleeping figures in the foreground with Christ kneeling in prayer some distance behind. Benvenuto di Giovanni's painting is unusual in

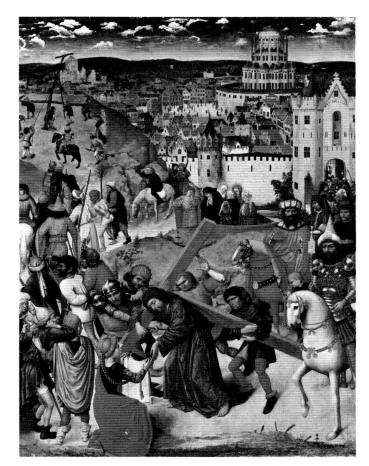

Unknown Flemish Artist: *Road to Calvary*, 108 × 82cm

showing the other eight disciples, also sleeping, grouped behind a rocky ridge. Benvenuto's composition includes a very domestic-looking fence in the right foreground, and similar fences or palings are frequently shown, presumably to suggest the idea of a garden. If this may appear to be a superfluous reference in view of the unmistakable nature of

Benvenuto di Giovanni: *Agony in the Garden*, 43·5 × 48·5cm. c.1500

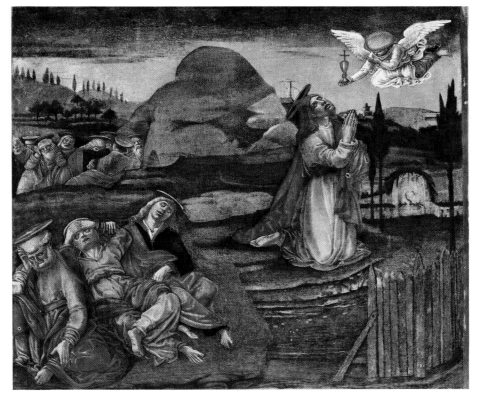

the subject, another element in Benvenuto's painting shows an equally common and more confusing instance of over-literal translation of the Gospels.

Christ, knowing that he was betrayed and that an agonizing ordeal awaited him, had his human and divine natures thrown into conflict and prayed to God that he might be spared. The Evangelists report that he prayed three times 'Saying, "Father, if thou be willing remove this cup from me: nevertheless not my will but thine be done." And there appeared an angel unto him from Heaven, strengthening him' (Luke 22:42–3). Benvenuto's painting shows the angel, but, in common with numerous other representations, it is seen proffering a chalice or cup. The cup referred to in Christ's prayer is quite obviously the figurative one which often appears in the Scriptures, and in this context can be taken to mean 'fate' or 'lot'. In translating a figure of speech into visual terms, the painter can hardly avoid investing a verbal metaphor with the aspect of reality. Consequently, like so many other interpretations of the subject, the painting shows an ironical inversion of sense, by equipping the supposedly comforting angel with the symbol of the very fate shunned by Christ. When the cup is surmounted by a cross, as it is in Benvenuto's painting, its resemblance to a

Eucharistic chalice causes a further degree of confusion. Although Mantegna's *Agony in the Garden* (1459) carries this misinterpretation still further by introducing five small angels carrying the instruments of the Passion, it is probably one of the most impressive depictions of the subject.

Mantegna: *Agony in the Garden*, 63 × 80cm, and detail, c.1459

Mantegna employs the common device of placing the three sleeping disciples in the foreground, but he introduces an unusual iconographic element of five small angels, carrying the instruments of the Passion, the column, cross, lance, and sponge, and replacing the more usual symbol of an angel with a cup. The figure of Christ is composed and monumental, isolated against the dramatic setting of the city of Jerusalem, which stands beneath a towering granite outcrop. Judas approaches in the middle distance, pointing out the way to the procession of soldiers and chief priests, which winds down the slope from the city gate. This is an effective dramatic device. As Christ prays that he may be spared the agonies that await him, the inescapable reality of his fate advances, only yards away.

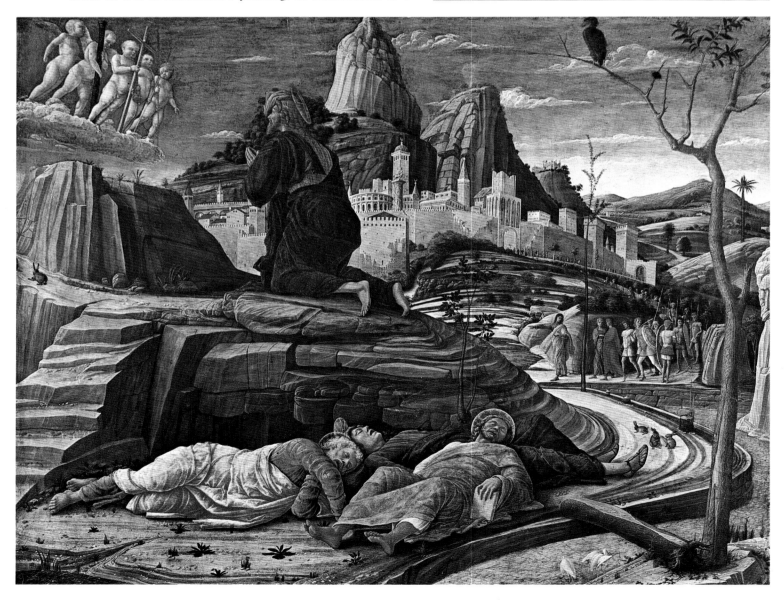

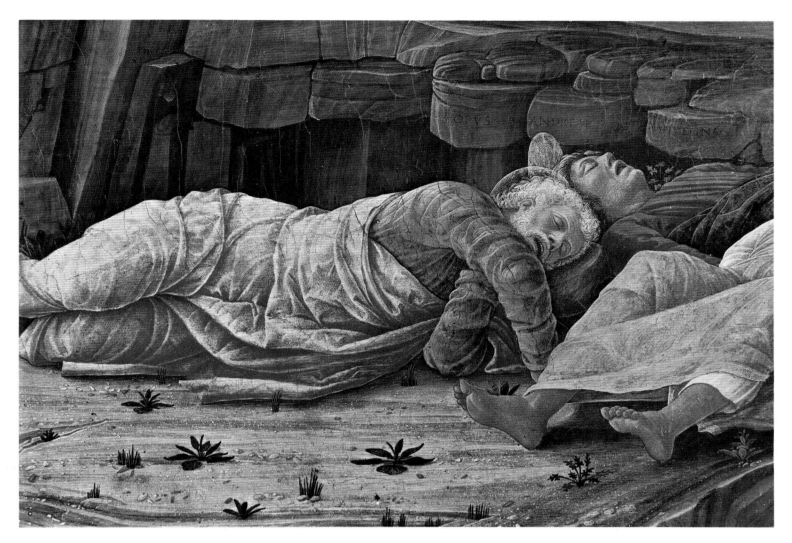

While Christ and the disciples were still in the garden of Gethsemane a crowd appeared, armed with swords and staves, led by Judas who identified and betrayed Christ with a kiss. All the four Gospels mention the kiss of Judas and the incident of Peter drawing his sword and cutting off the ear of Malchus, the servant of the high priest. Most paintings of the Betrayal, Arrest, or Capture of Christ show these two central incidents, contrasting Christ's calm and sorrowful response to Judas' teacherous embrace, with Peter's violent act and the general display of aggression from the arresting party. However, in examples of the subject up until the early fourteenth century, the interpretation most often given exploited the two miraculous incidents recounted only by John and by Luke. Luke describes how Christ miraculously restored the severed ear of Malchus. John reports that when challenged about his identity, Christ replied simply, 'I am he', and the soldiers were struck down momentarily by a supernatural power. Fra Angelico's *Betrayal* combines the kiss of Judas with the prostration of the guards, whereas the version by Duccio includes a reference to the healing of the ear. Duccio shows Christ already lifting his hand in a healing gesture as Peter's knife slices the servant's ear from his head. To the right of the composition the rest of the disciples are seen fleeing, an incident mentioned by both Matthew and Mark, but one that is seldom depicted. Giotto's *Betrayal* concentrates exclusively on the human drama of the subject, focusing formal and emotional attention on the treacherous kiss. The later conception of the scene as represented by Van Dyck abandons this economical approach for a more dramatic effect that exploits the full potential of a night-time setting and emphasizes the violence of the arrest with a dynamic surge of figures towards the passive and upright figure of Christ. Judas clasps Christ's right hand and stands on the edge of his cloak, the better to prevent any attempted escape. Behind him, two figures with ropes prepare to bind the captive. The scene is illuminated by blazing torches and a crescent moon, which produce extreme contrasts of light and shade and reinforce the impression of a sinister and violent ambush.

Van Dyck:
Christ Arrested,
344 × 249cm.
c.1618

21

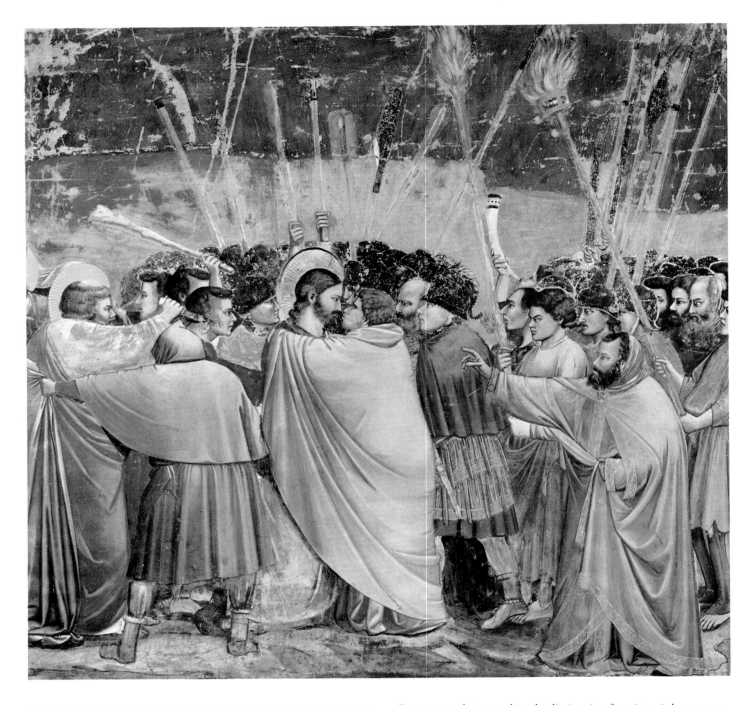

There is considerable diversity in the Gospel accounts about what transpired after Christ's arrest. By consulting the four Evangelists, it appears that a series of semi-judicial proceedings took place, all essentially similar, and none offering anything strikingly distinctive for pictorial purposes. The main feature in painting of these five separate trials, is the contrast between the divine dignity and composure of Christ and the calculated meanness and ignorance of men. Although it was not common for Passion cycles to show more than one or two of these episodes, Duccio shows the whole series, the appearances before Annas, Caiaphas, Pilate, Herod, and Pilate once again. This dramatic repetition may well have been influenced by the conventions of the mystery plays, where the effect of such a succession would be more easily discernible. Duccio links the episode of Christ before Annas, which is only mentioned by John, with the panel depicting Peter's first denial of Christ. His *Christ Mocked before Caiaphas* also includes the related incident, detached from the main scene by an archway, of Peter denying Christ for the third time as the cock crows about him. The Denial of Peter was occasionally treated as a separate subject and is given a particularly impressive emotional effect in a painting by Rembrandt.

In general, paintings of the various trials, apart from the final appearance before Pilate, were relatively uncommon.

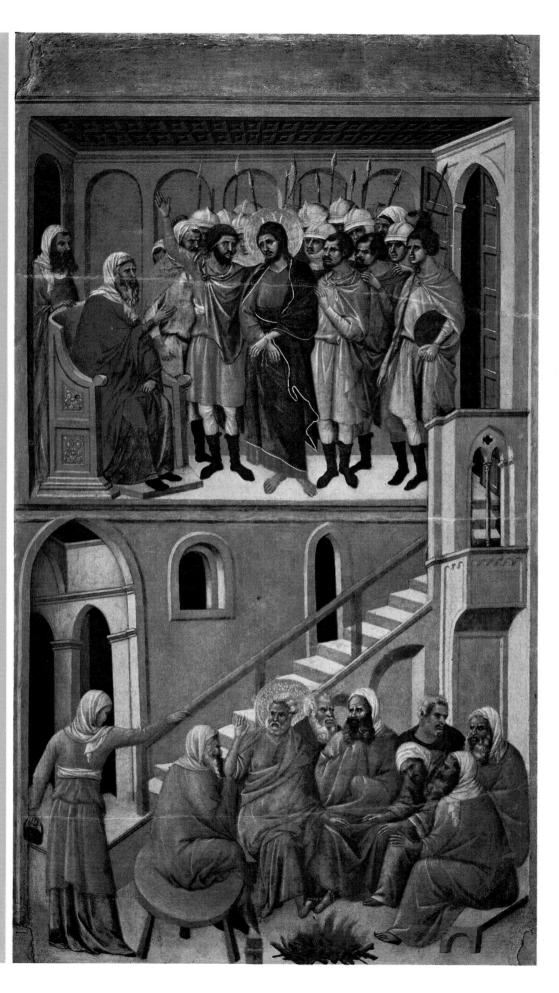

Duccio: *Christ before Annas* and *Denial of St Peter*, 1303–5

Duccio gives a cross-section through the building thus incorporating two episodes into the space of one panel. As there is little of pictorial interest to distinguish Christ's appearance before Annas, the linking of this episode with Peter's first denial establishes a sense of dramatic tension and pathos. At the very moment that Christ is being accused by his enemies, his disciple, who has followed at some distance and gained access to the building, denies all knowledge of him. Peter, seated with a group of servants around an open fire in the inner courtyard, is accosted by a passing serving girl; she recognizes him as a follower of Christ, but this he denies. In the upper room, Duccio has introduced the servant raising his hand to strike Christ, an incident which actually belongs to the succeeding episode of Christ's appearance before Caiaphas.

When they were depicted, confusion could easily arise over the precise identity of the event. There was a similar possibility of confusion in the differentiation of the 'mockings' of Christ, which took place in relation to his appearances before Caiaphas, Herod, and Pilate, and which offered more varied material than the depiction of the successive tribunals. The Mocking before Caiaphas took place after Christ, when asked whether or not he was the 'Son of God', had answered in the affirmative, and had been accused of blasphemy. The mocking and derision which consequently took place is readily distinguished by the descriptions of Mark and Luke: 'And some began to spit on Him and to cover His face, and to buffet Him, and to say unto Him, Prophesy: and the servants did strike Him with the palms of their hands' (Mark 14:65). This subject was particularly common in Northern painting of the fifteenth and sixteenth centuries. One of the most impressive examples is Grünewald's *Mocking of Christ* of 1503, his earliest verifiable work, which emphasizes the pathetic humiliation of Christ's predicament, and the malicious violence of his tormentors.

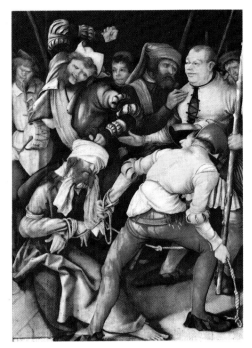

Grünewald:
Christ Mocked,
109 × 73 cm, 1503

Holbein the Elder: *Flagellation,* 142 × 85 cm, 1502

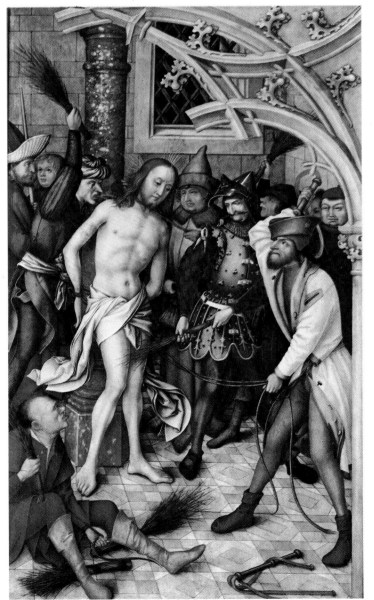

The Second Mocking, before Herod, is only mentioned by Luke who reports that Herod's captains first dressed Christ in a 'gorgeous robe' before deriding him. This incident is rarely shown either in Passion cycles or as an individual subject, probably because of the similarity between this robe and the purple robe which is seen in the third mocking. The second appearance before Pilate is, however, depicted fairly frequently as it is the concluding episode in the series of trials, and includes the distinctive feature of Pilate washing his hands. Christ had been brought before the governor by the chief priests and elders who wished to have him put to death, but as a Passover custom the governor could release one prisoner at the people's demand. Prompted by the elders to ask for the release of Barabbas, the people demanded that Christ be crucified. 'When Pilate saw that he could prevail nothing, but that rather a tumult was made, he took water, and washed his hands before the multitude, saying, I am innocent of the blood of this just person: see ye to it' (Matthew 27:24). This is the moment commonly shown in paintings of Christ before Pilate. Tintoretto's composition from the cycle at the Scuola di San Rocco shows Christ dressed in a brilliant white robe (which symbolizes his innocence) standing serenely before Pilate who averts his eyes from the doomed man as he washes his hands. Pilate's reluctance to look directly at Christ is often allied to an expression of perplexity on his face, as he attempts to reconcile his conviction that his prisoner is innocent with his fears of provoking a riot if he releases him.

Following the custom of the day for condemned prisoners, Pilate delivered Christ to the soldiers to be scourged. The episode of the Flagellation appears in the majority of Passion cycles and was frequently presented as an independent subject. To the Italian painters of the Renaissance it provided an opportunity to depict an almost nude body idealized in its gracefulness or muscularity. To Northern painters of the same period the subject gave *carte blanche* for displays of extreme sadism, indignity, and suffering. Consequently, there

is a wide diversity of approach to this subject, ranging from the graceful refinement of Signorelli's *Christ at the Column* to Holbein the Younger's gruesome *Flagellation*. Holbein the Elder's *Flagellation* shows a certain amount of restraint, and although the soldiers have raised their scourges to administer obviously malicious blows, Christ has not yet been marked and maintains an expression of calm dignity. This is more than can be said for Holbein the Younger's treatment of the same subject. He shows Christ's features contorted in a rictus of fear and pain as he writhes, entirely naked, under the lash. It was not common to show Christ naked during the scourging, and it seems likely that Holbein was influenced by St Bridget's *Revelations* where Christ's body is described as being completely bared to the blows so that no part of it was spared.

This type of embellishment on the facts given by the Gospels was partly responsible for the variation in approach to the Flagellation. Theologians held different opinions about whether Pilate, tending towards leniency, would have proscribed excessive cruelty, and whether or not the soldiers had been bribed to be totally unsparing. Paintings

Titian: *Christ Crowned with Thorns*, 180 × 182cm, c.1550

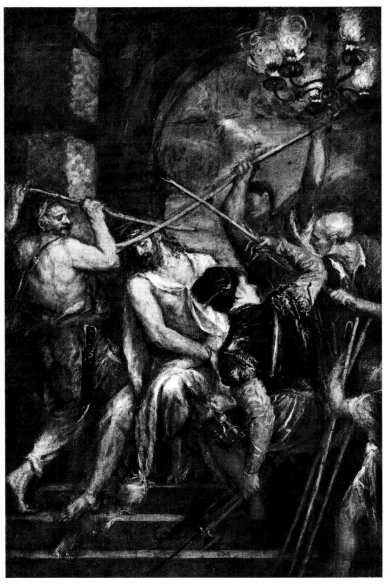

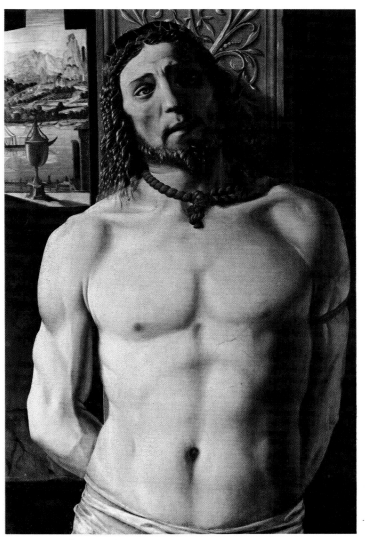

Bramante: *Christ at the Column*, 62 × 93cm, c. 1490

of the Flagellation are more or less equally divided between enthusiastic depictions of gloating cruelty, torn flesh and rivulets of blood, and compositions of graceful and rhythmic symmetry with minimal reference to brutality, mutilation, and suffering. An unusual and forceful interpretation of the subject is seen in Bramante's *Christ at the Column*. Here the half-length format of the composition, the absence of the soldiers, and the lack of overt action, concentrates attention exclusively on the solitary figure of Christ. This device allows a more empathetic view of the victim whose apprehensive expression appears to register the approach of the soldiers, their scourges at the ready. Bramante's composition is also unusual in showing Christ tied to a squared pier rather than the usual column, and in the viridescent hue of the face, doubtless caused by the rope tied tightly around the neck.

Following the Flagellation, the Third Mocking, by Pilate's soldiers, took place, and is described by Matthew, Mark, and John. All recount that Christ had a purple (or scarlet) robe thrown over him, a reed put into his hand and a crown of thorns on his head (as mock symbols of power), and was jeered at by the soldiers. This episode, with its very distinctive features, is frequently shown in preference to the earlier two mockings. The most common treatment of the subject concentrates on the actual crowning with thorns. A particular convention for the depiction of this subject was established early on and became the norm from the fourteenth century. This was the presence of two figures, one on either

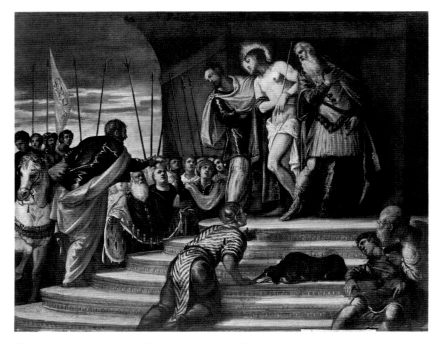

Tintoretto: *Ecce Homo*, 109 × 136cm, c.1560

Cerezo the Younger: *Ecce Homo*, 98 × 75cm, c. 1670

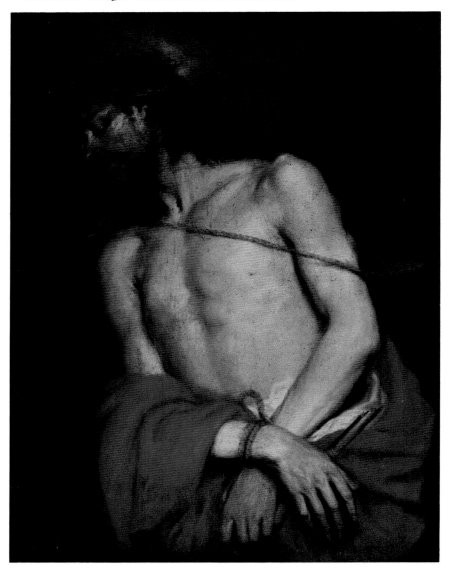

side of Christ, who force the crown onto his head with two long staves. This produces a curious effect, often suggesting an inappropriate excess of engineering to accomplish a relatively simple task. This exaggeration is even more apparent in Titian's *Christ Crowned with Thorns*, where a third figure brandishes a stave which interlaces with the other two, forming a lattice of straight lines, which contrasts with the overall atmospheric looseness of the painting. The alternative to the convention of the staves was to show the crown being pressed onto Christ's head by a soldier wearing a mail, or plated, gauntlet such as that seen in *Christ Mocked* by Hieronymous Bosch.

John's Gospel is alone in relating that Christ was led out wearing the robe and crown of thorns and carrying the reed sceptre, and that Pilate addressed the crowd with the words, 'Behold the man!' This subject, Christ Presented to the People, otherwise known as the Ecce Homo, is not a principle episode in the Passion cycle. It does not appear at all in early art, is not incorporated into Duccio's cycle, and is scarcely seen before the fifteenth century. There were two distinct approaches to the subject. The first was to present a full historical composition, usually showing Christ on a balcony or at the top of a flight of stairs, accompanied by Pilate and his soldiers and with a crowd looking on. In common with the preceding episodes, this subject is often treated as a confrontation between good and evil, where corruption, cruelty, and vituperation, contrast with innocence,

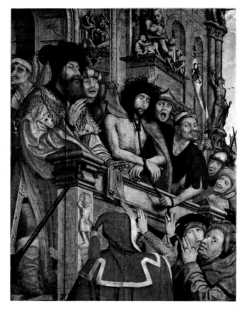

Metsys:
*Christ Presented
to the People*,
160 × 120cm.
1515

resignation, and dignity. This is seen in *Christ Presented to the People* by Quentin Metsys, but the contrast of types is less extreme in Tintoretto's *Ecce Homo*.

The second approach to the subject, which became increasingly common during the seventeenth century, was the depiction of the Ecce Homo as a devotional image. This presents the solitary figure of Christ, with Pilate's words interpreted as an enjoinder to contemplation on the part of the spectator, rather than being placed in their historical context as an address to the crowd. Matteo Cerezo's *Ecce Homo* shows the characteristic features which typify such objects of piety. They almost always show Christ half-length,

with his hands tied before him, holding the reed sceptre and wearing the purple cloak and crown of thorns.

Whether given as a devotional image or as a historical composition, the *Ecce Homo* presents the passive, stupefied victim of a succession of overwhelming emotional and physical ordeals. An objective appraisal of these episodes of

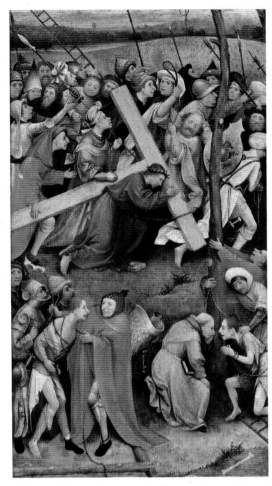

Bosch: *Christ Carrying the Cross*, 57 × 32cm

forceful arrest, repeated questionings before various biased authorities, brutalization, humiliation, and the hypocritical compromises of corrupt officialdom, results in a depressing sense of familiarity. This section of episodes from the Passion is perhaps the most comprehensive and relevant account, left by art throughout the centuries, of man's unchanging capacity for murderous prejudice, systematic injustice, and culpable cruelty. If in this case the victim is exceptional, the persecutors and their methods are drearily commonplace.

As the *Ecce Homo* is seldom incorporated into Passion cycles, the episode of the Flagellation is usually followed immediately by the subject of Christ Carrying the Cross or of the Road to Calvary. Matthew, Mark and Luke recount that as Christ was led away to be crucified, Simon of Cyrene, a passerby, was enlisted to carry the cross. John's Gospel alone relates that Christ was compelled to carry his own cross. A number of the earliest representations of the scene, and also that which appears in Duccio's cycle, show Christ unencumbered while Simon walks on ahead carrying the cross himself. This interpretation disappeared quite rapidly in favour of the depiction of Christ himself bearing the cross, usually with only marginal assistance from the Cyrenian.

Before the fifteenth century paintings of Christ Carrying the Cross, such as that by Simone Martini, either placed Christ directly in the foreground, or at least clearly defined his person by setting it slightly apart from the accompanying crowd. During the fifteenth and sixteenth centuries, the Road or Procession to Calvary is frequently overcrowded; large numbers of figures and fanciful anecdotal details vie for attention with the figure of Christ staggering beneath the weight of the cross. Bosch shows Christ in the middle-distance, while the foreground is occupied by the two thieves accompanying him to execution who are engaged in their own separate dramas, one being bound by a soldier the other,

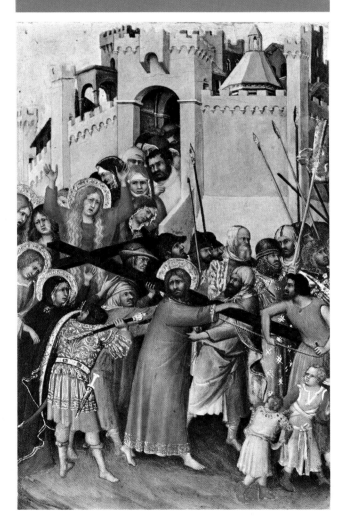

Bassano: *Road to Calvary.*
94 × 114cm, c. 1570

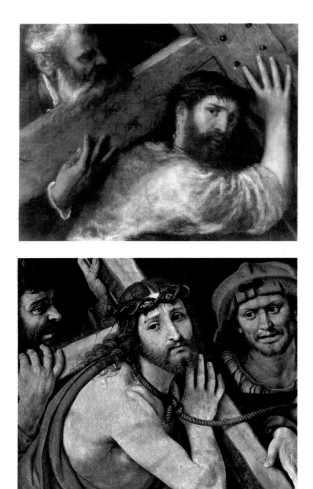

Solario: *Christ Carrying the Cross.* 58 × 67cm. 1511

TOP **Titian**: *Christ and the Cyrenian*, 98 × 116cm.
98 × 116cm. c. 1560

incongruously, making a last confession to a crouching
priest.

Jacopo Bassano's *Procession to Calvary* is filled with a
crowd of densely packed figures with Christ barely discernible
in their midst. He is surrounded by St Veronica and the
Daughters of Jerusalem as he falls beneath the cross. The

Master of St Veronica:
St Veronica, 78 × 48cm.
early 15th century

falling is frequently shown in sixteenth century paintings of
the Procession, and although not mentioned in the Gospels,
it appears three times in the fourteen Stations of the Cross
and was presumably introduced as an additional element of
pathos. Two other elements of Bassano's painting, Christ
encountering the Daughters of Jerusalem, and St Veronica
about to wipe his face with her veil, exist as separate episodes
in the Stations, although neither has any Biblical authority.
The legend of St Veronica and her veil was widely circulated
during the early Middle Ages and had its source in the
apocryphal Gospels of Nicodemus. The legend recounts that
having wiped the sweat from Christ's face Veronica dis-
covered that the cloth had miraculously recorded a perma-
nent imprint of his countenance. When not incorporated
into scenes of the Procession, Veronica and her veil exist
independently as a devotional image. Another such image

El Greco: *Christ Stripped of his Garments.* 165 × 99cm. c.1589

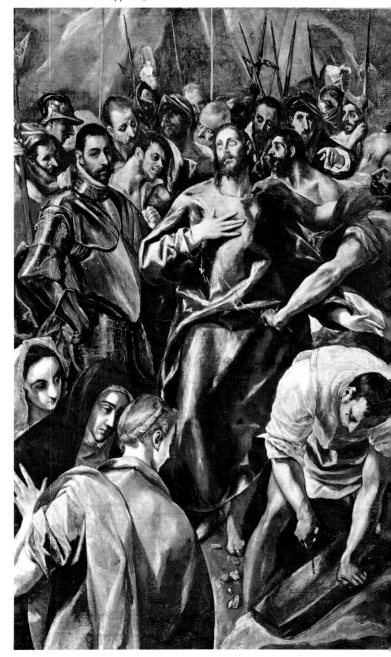

Cornelius van Oostsanen: *St Veronica* (detail from *The Calvary*)

Cathedral, was commissioned in 1579, and El Greco subsequently produced several repetitions including the composition at Munich which was painted approximately ten years after the Toledo composition. Christ is shown having his garments dragged from him, while in the foreground, the Virgin and two of the Holy Women are watching a carpenter who bores a hole at the end of one of the trans-

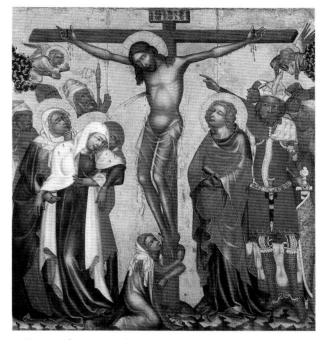

Master of Vyssi Brod: *Crucifixion*, 99·5 × 92·5cm, c.1350

derived from the Procession, and like the Ecce Homo seen most frequently during the early fifteenth and the sixteenth centuries, is the quarter-length painting which shows Christ with the cross on his shoulder. More often than not, Simon of Cyrene is also shown, as he is in the paintings by Titian and Solario.

An episode presumed to have preceded the Crucifixion, Christ Stripped of his Garments, is not mentioned by the Gospels but also appears as one of the Stations of the Cross. It is extremely rare for this subject to occur in a Passion cycle, although it does occasionally appear as an independent subject. When it is depicted, it is usually accompanied by another incident relating to the impending execution. The best known, and most dramatic interpretation of the event is seen in the versions by El Greco. The original, at Toledo

verse beams of the cross. This interesting feature seems to have been inspired by the visions of the irrepressible and consistently morbid St Bridget. Her *Revelations* recount that, before Christ was laid on the cross, holes were first bored to accommodate the nails. His right hand having been secured, she reports that the space between the holes was found to

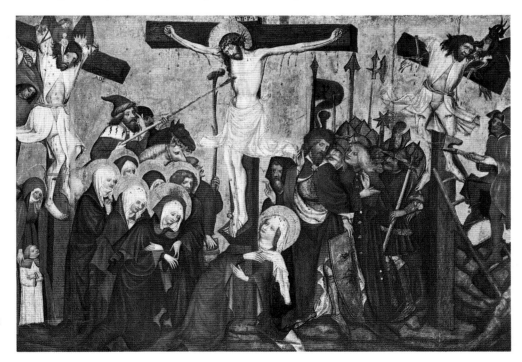

Master of the Rajhrad Altar: *Crucifixion*, 101 × 142cm, early 15th century

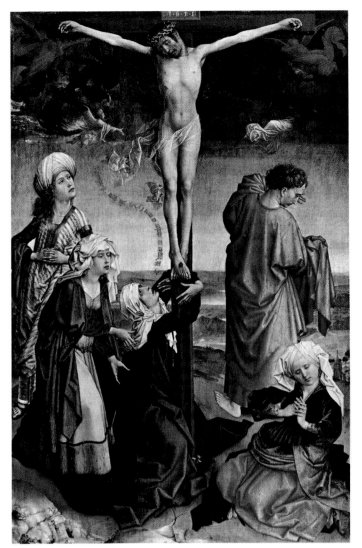

Master of Flémalle: *Christ on the Cross.* 77 × 47cm. 1435–40

be too great so that the left arm had to be stretched with a rope until it reached the required position.

No such practical details are mentioned in the Gospels, all of which agree on the basic fact that Christ was crucified along with two thieves, that a notice describing him as 'King of the Jews' was fixed above his head, and that lots were cast for his garments. Although each of the Evangelists elaborates on these features by describing related elements, art itself has elaborated to such an extent on what remains a minimal account that the variations in approach are innumerable.

The Crucifixion is the central episode of the Passion cycle, and as an independent subject has proliferated beyond all others in Christian art. It has already been noted that this was not originally the case and that the image, which for centuries has been central to Christianity, was in fact shunned by the earliest Christians. Early Christian art continued to be influenced by classical ideals of nobility, decorum, calm grandeur, and physical beauty, ideals which were difficult to reconcile with the depiction of such an eminently unsuitable subject as the Crucifixion. Aesthetic considerations were combined with the realistic rejection of an event whose horror and ignominy continued to present a threat. Even now, when viewed objectively, the Crucifixion is in pictorial terms a disturbingly awkward image of a singularly agonizing, and maliciously ingenious system of torture and execution. For all its familiarity, the image of this event, whose historical dimension co-exists with its significance as the embodiment of an axiomatic tenet of faith, continues to exert a faintly uncomfortable sense of the anomalous and inadmissable. This is perhaps less attributable to the superficial appearances of physical suffering than

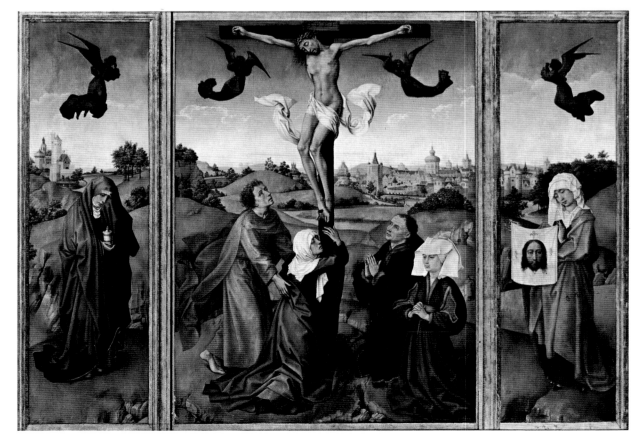

OPPOSITE **Masaccio:** *The Crucifixion.* 83 × 63·5cm, 1426

Van der Weyden: *Crucifixion Triptych,* central panel 101 × 70cm, side panels 101 × 35cm, c.1440–50

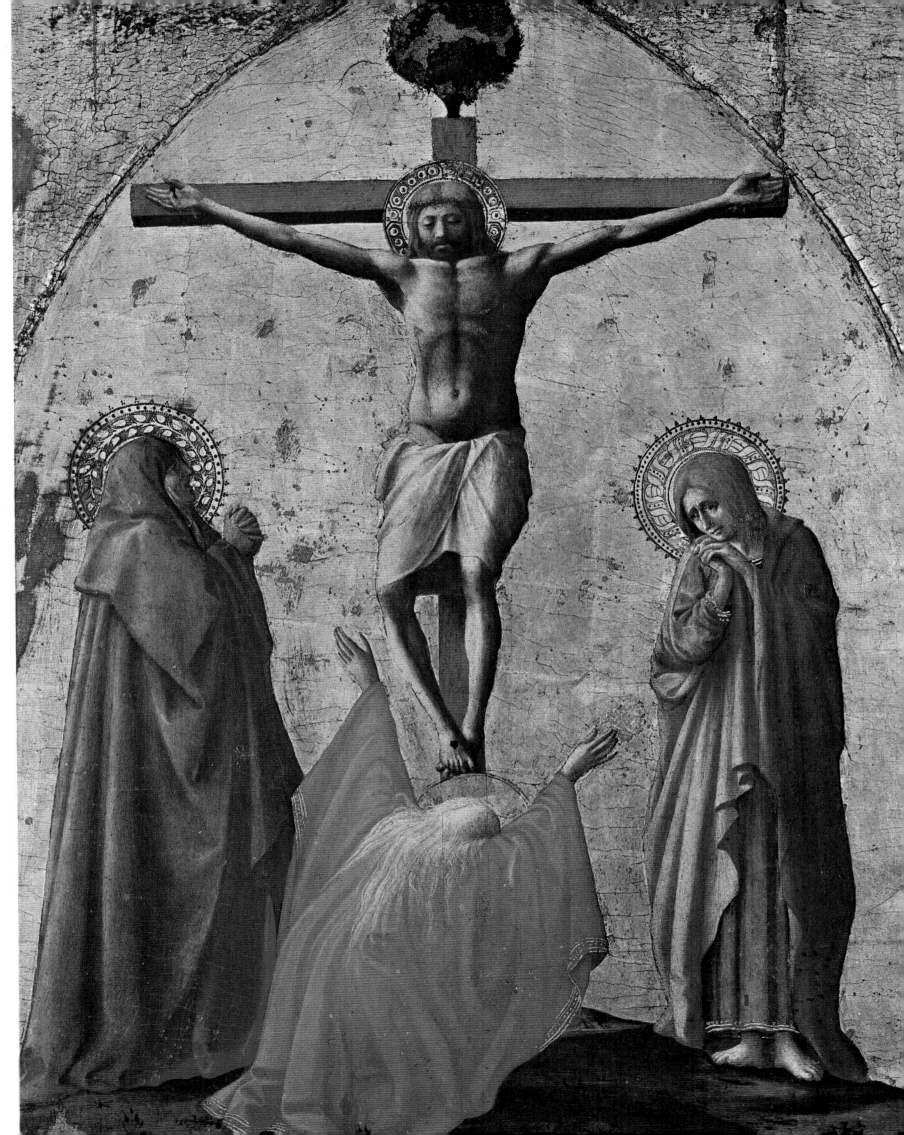

Mantegna: *Calvary*, 67 × 93cm, 1459

This *Crucifixion* is the central panel from the predella of the altarpiece painted by Mantegna for the church of San Zeno in Verona. The other predella panels are the *Agony in the Garden* and the *Resurrection*. This spectacular, though surprisingly small composition, brings a new interpretation to the subject through Mantegna's preoccupation with historical exactitude and precise perspective. Mantegna is almost unique in depicting a Golgotha with the convincing effect of an actual location. If the figures were removed, the site would retain its threatening and lugubrious atmosphere. The flagged terrace is more starkly functional and suggestive of an official execution area than the more common grassy knoll. The cavities between the flag-stones where crosses have been previously wedged, add an archeological dimension, fixing the Crucifixion in historical terms as being one of a countless number of executions. The location of St John, the Virgin, and the Holy Women is unusual in having been shifted to the left so that they are grouped at the foot of the 'good thief's' cross.

Opposite **Antonello da Messina:** *Crucifixion*, 52·5 × 42·5cm, 1475

Antonello sets the figures of Christ, the two thieves, the Virgin, and St John in an extensive landscape of simple, well defined volumes, beneath a limpid sky. The careful construction, objectivity, and clarity of the composition, the restrained composure of St John and the Virgin, and the austerity of the Christ, give an impression of serene impassivity. This mood has a dramatic counterpoint in the rhythmic contortions of the thieves, who are shown tied to lopped, but living trees. Although distinctions between the Christ's execution and those of the thieves were necessary in early art, in this case they are a straightforward attempt to gain a variety of pictorial effect by departing from the familiar convention. Christ is depicted as already dead. The 'good thief' has had his legs broken in order to speed his death, and appears to have expired. However, Antonello shows the 'impenitent thief' as still writhing in agony, presumably having been refused the mercy of a hasty dispatch, and thus he symbolizes the fate of those whose lack of penitence would condemn them to endless torment.

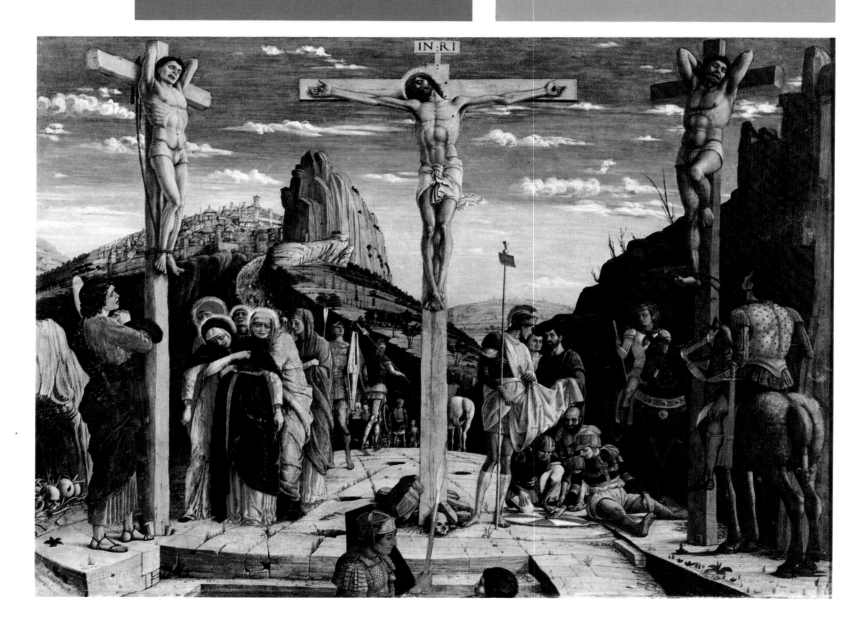

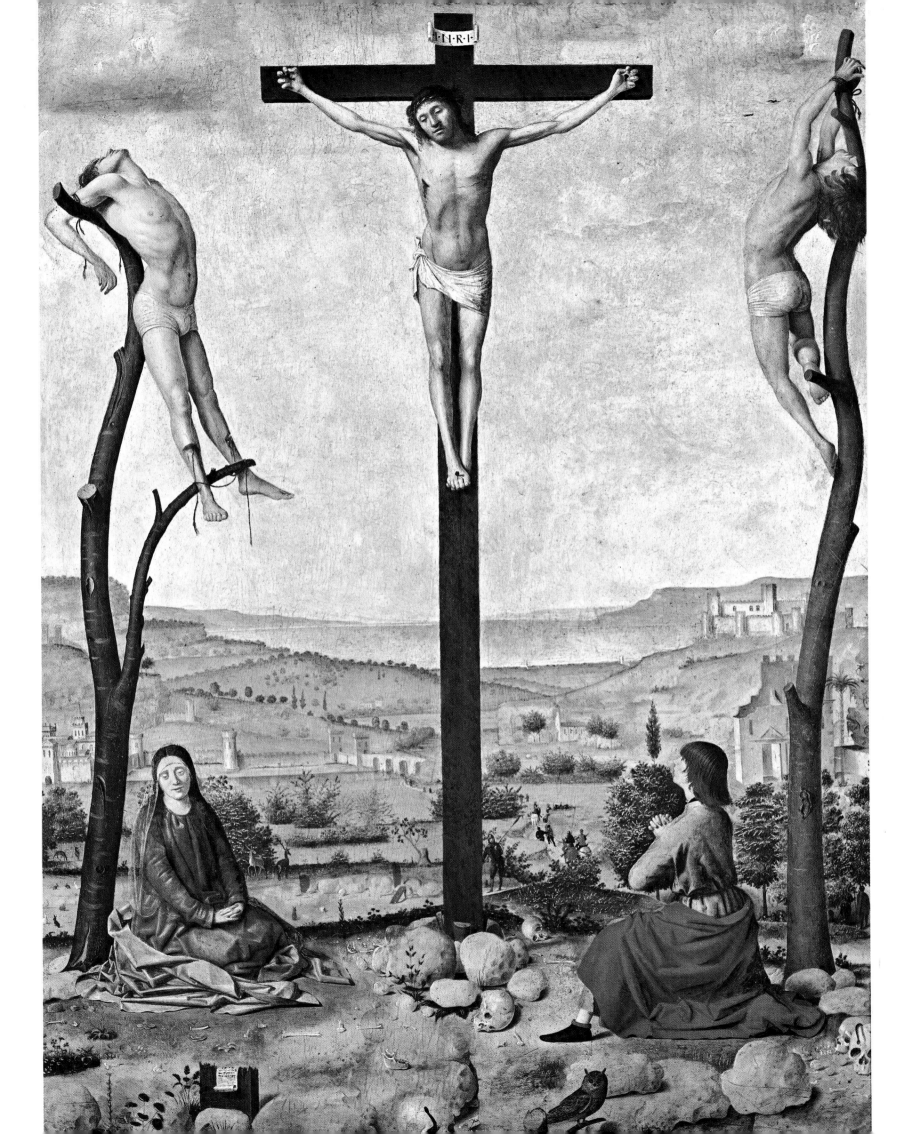

to the relationship between a contorted organic form and the stark geometrical regularity of the cross.

This particular effect is conveyed by naturalistic painting, but early crucifixes and panels showing the Crucifixion with Christ upright, his body almost exactly parallel with the rigid linearity of the cross, give a different impression. These formal qualities symbolized self-sacrifice, and in showing Christ physically aligned with the cross they represented his voluntary acceptance of the instrument for the accomplishment of his redemptive mission. This type of image was a direct appeal to faith and was reinforced by the presence of the Virgin and St John standing by the cross. Although John reports his own presence and that of the Virgin at the Crucifixion, none of the other Gospels mention it. In spite of this, the figures of John and the Virgin appeared early on and

remained as the most important and most frequently represented figures at the Crucifixion. As the affirmation of faith gave way to an appeal to the emotions, the Virgin and John lost their symbolic supportive significance and began to be depicted expressing grief and anguish.

The *Calvary of Hendrix van Rijn* by the Master of the Low Countries, shows the continuing symbolic form of the Crucifixion in International Gothic painting. Here there is minimal emotional expression and the simplicity and balance of the composition with its decorative gold background typifies the symmetry which, while being an important feature of medieval expression, is also an element of intrinsic importance to the Crucifixion in general.

When historical rather than doctrinal considerations begin to influence the depiction of the Crucifixion, and the

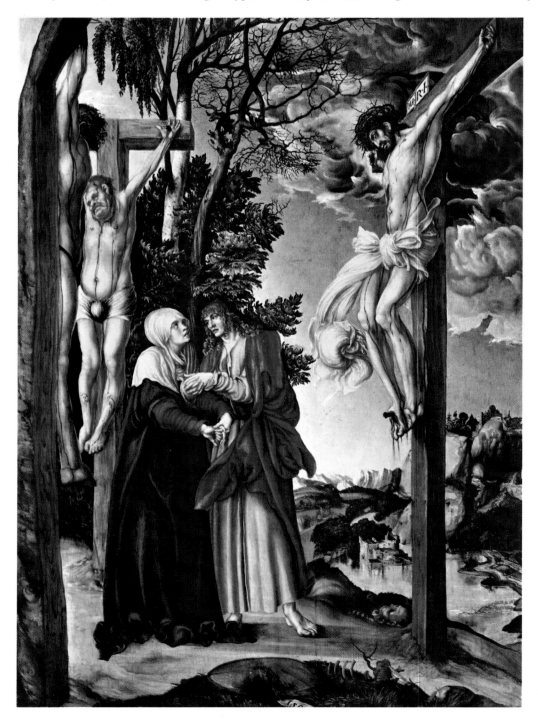

Cranach the Elder: *Crucifixion*,
138 × 99cm, 1503

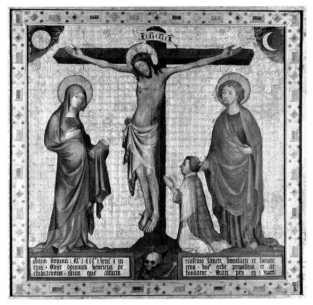

Master of the Low Countries: *Calvary of Hendrix van Rijn.* 130 × 133cm, early 14th century

two thieves are added to the presence of John and the Virgin, the symbolic symmetry of the composition is augmented. The Gospels relate that two thieves were crucified along with Christ, one on his left, the other on his right. Luke alone distinguishes between the two, recounting that while one joined in with the vilification of Christ, the other was penitent and was promised salvation. Although no reference is made to their respective positions, the 'good thief' is invariably shown at Christ's right, and is further distinguished by a lesser degree of suffering and contortion than the 'impenitent thief' who is often shown turning away from Christ. The symbolic symmetry of the Crucifixion remains constant and explains the traditional location of positive elements, such as the Virgin, the sun, the 'good thief' on Christ's right, and negative elements, like St John, the moon, the 'impeni-

Cranach the Elder: *Crucifixion*, 121 × 82·5cm, 1533

Cranach's *Crucifixion* of 1503 is striking not only through its unusual composition but also because of the importance of its wild landscape setting. In this *Crucifixion*, painted thirty years later, there is no trace of landscape and every inch of canvas is filled with figures. Over-populated compositions such as this tended to show an interest in humanity rather than a concern with historical exactitude or theological precision. It is the Northern painters who most often crowd their *Crucifixions* with an extraordinary and frequently ill-assorted array of figures enlivened by caricature and anecdotal detail. Cranach shows the soldiers casting lots for Christ's garments, the Virgin fainting, and Longinus the centurion recognizing the divinity of Christ. The thieves, one of whom is grotesquely obese, are nailed to their crosses, their feet transfixed by two nails; although this feature appears in Duccio's *Crucifixion*, it is most unusual after the early fourteenth century. Cranach was a lifelong friend of Luther, and his many paintings of the *Crucifixion* reflect the spirit of the Reformation.

Pages 38–9. **Cranach the Elder:** *Crucifixion* (detail)

tent thief' on the left. St John is something of an exception in this context but was relegated to the left when he and the Virgin replaced allegorical figures of the Church and Synagogue in early symbolic interpretations of the Crucifixion.

Throughout the centuries most paintings of the Crucifixion adhered to compositional and symbolic symmetry, and the scene was usually represented from a square-on viewpoint. One of the most remarkable exceptions to this convention is Cranach the Elder's *Crucifixion* of 1503, which is seen from a dramatically oblique angle. The inventive, almost photographic device, of framing the left of the composition by the bisected upright of the cross, combines with the low-angled viewpoint to draw the eye into the composition. This replaces the more characteristic remoteness of the scene with an effective sense of proximity.

A further type of Crucifixion scene which shows the basic figures of John and the Virgin but does not normally include the thieves, is the devotional composition where the main figures are joined by various saints. Although Mary Magdalene is often shown, particularly during the Renaissance, she is described by the Gospels as having been present at the Crucifixion, and her depiction is historically justifiable. On

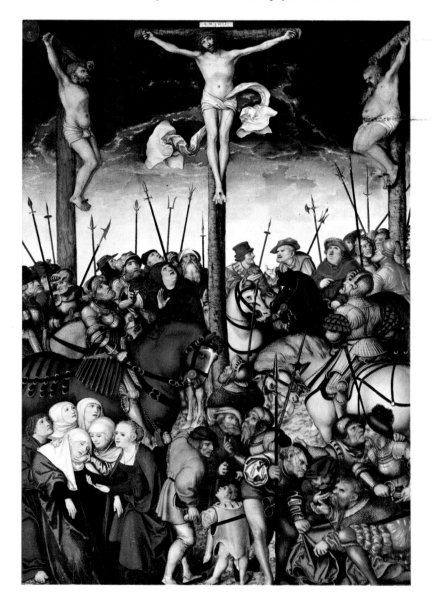

the whole, however, the saints depicted in devotional Cruci-
fixion pictures have no historical connexion with the event
and are usually incorporated because of their particular
devotion to the Passion of Christ. The inclusion of certain
saints also depended on the intended location of the painting
and the body which had commissioned it. Consequently,
when intended for a monastery or convent, the painting
most frequently depicted the founder of the order, and when
destined for a church, the saint would be the patron saint or
a saint with particular local significance. The frequent in-
clusion of two saints increases compositional symmetry and
Raphael's *Crucifixion* exploits this type of formal balance to
the full. St Jerome and Mary Magdalene are shown kneeling
in front of the Virgin and St John, and the balance of the
composition is amplified by the sun and moon, the angels
hovering on either side of Christ, catching his blood in up-
lifted chalices, and the decorative arabesques of their
drapery.

When the Crucifixion occupies the central panel of a
triptych, the accompanying saints are usually painted on
the side panels, as they are in van der Weyden's altarpiece.
This shows the donor and his wife kneeling opposite the
Virgin and St John at the foot of the cross, while Mary

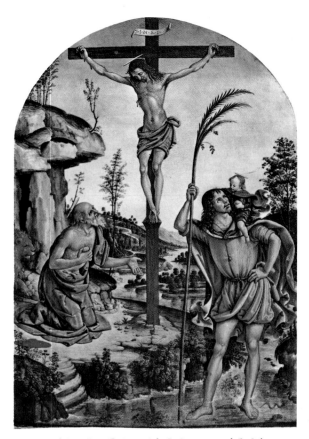

Pinturicchio: *Crucifixion with St Jerome and St John,*
50 × 40cm, c.1500

Magdalene and St Veronica are situated on the side panels.
The triptych by Josse van Cleve shows Mary Magdalene in
the central panel, and the donor and his family have been
relegated to a more respectful position on the side panels.
Devotional paintings such as Pinturicchio's *Crucifixion with
St Jerome and St Christopher* show no attempt at historical
accuracy, and the figure of Christ on the cross tends to be
given the characteristics of a crucifix rather than being
rendered naturalistically.

Compositions which added subsidiary figures to the basic

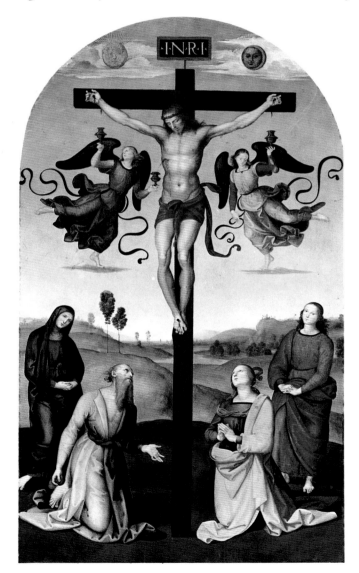

Raphael: *Crucifixion,* 279 × 166cm, 1503

Opposite **Rubens:** *Christ between the Two Thieves*
(known as the *Coup de Lance*), 429 × 311cm, 1620

Rubens depicts the episode, mentioned only by St
John's Gospel, when, after Christ's death, his side is
opened and the legs of the thieves are broken. Paint-
ings of this subject originally had a particular doctrinal
significance as the blood and water which issued from
the wound in Christ's side were seen as symbols of the
two major sacraments of the Church, the Eucharist and
the Baptism. Rubens painted his monumental com-
position for the Church of the Recollects in Antwerp.
To the right, a centurion on a ladder prepares to break
the legs of the 'unrepentant thief', whilst Longinus,
with a powerful thrust of the lance, pierces Christ's
side. Although the Virgin and St John occupy the
foreground, it is Mary Magdalene who attracts atten-
tion with her tearful and hopeless attempt at inter-
vention. Movement and tension fills the composition
apart from one area of stillness and repose – the dead
body of Christ hanging slackly from the cross.

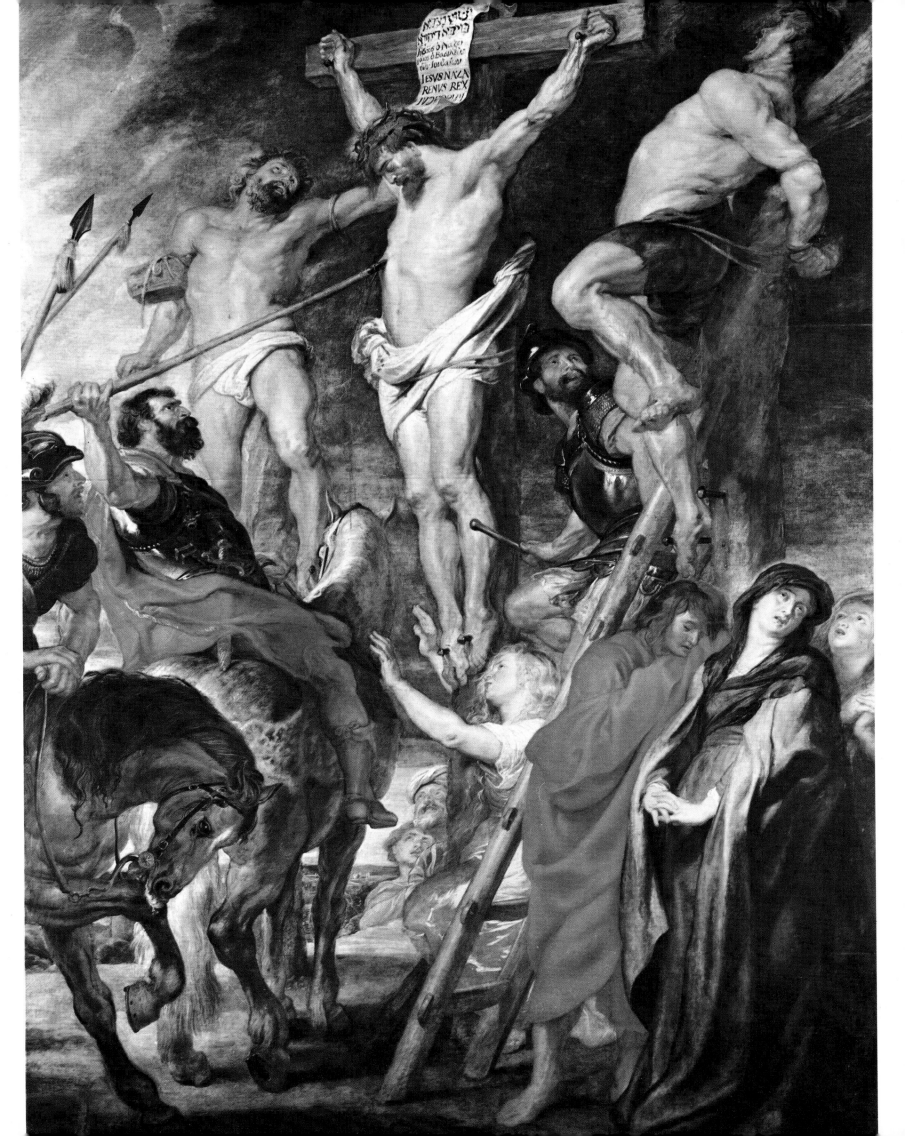

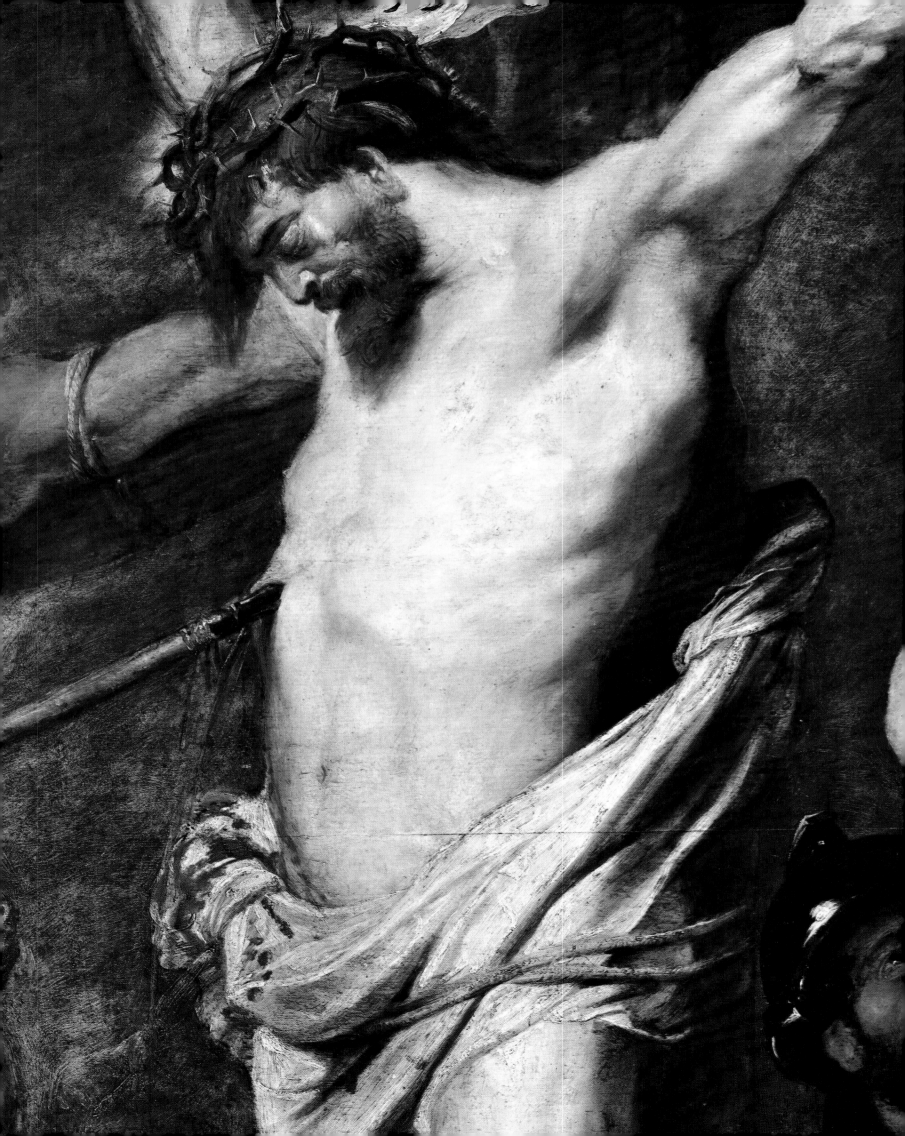

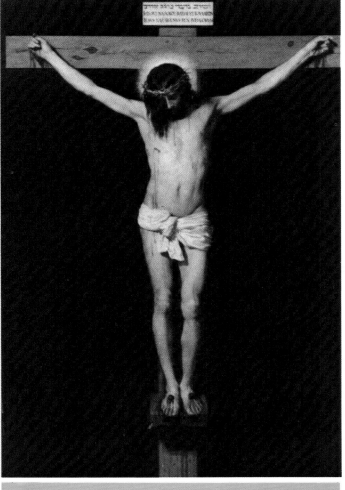

Velazquez: *Christ Crucified*, 248 × 169cm, 1630

This painting, from which all extraneous and anecdotal detail has been eliminated, shows Christ hanging dead after the lance thrust. It is a particularly powerful example of the economical treatment of the Crucifixion which appeared during the seventeenth century. In this type of composition, the landscape, if shown at all, is barely indicated and Christ is usually depicted against a darkened sky which conveys an emotional and dramatic effect far greater than the clear azure skies which predominated in the fifteenth and sixteenth centuries. Velazquez presents a powerful image of finality and desolation in his solitary figure of Christ, whose head has fallen forward, the hair obscuring half of the face.

Opposite **Rubens:** *Christ between the Two Thieves* (detail)

Veronese: *Crucifixion*, 149 × 90cm, c.1565

Veronese's approach to religious subjects tended to deviate from the requirements of the Counter Reformation. The Inquisition, which reinforced the standards set by the Council of Trent, took exception to his *Feast in the House of Levi* of 1573, which they accused of profanity and lack of decorum. Veronese's brilliant light and colour and sense of elation, was ill-suited to subjects such as the Crucifixion, and decorative effect concerned him more than theological accuracy or spiritual intensity. This *Crucifixion* shows a deviation from Counter Reformation dictates in the figure of the Virgin who has fainted into the arms of St John. This legendary incident, introduced by medieval art as a moving element of pathos, was condemned by the Council of Trent as an indecorous and misleading inaccuracy. The Gospel of St John, which alone mentions the presence of the Virgin at the Crucifixion, describes her as merely standing by the cross, and it was deemed that this was how she must be shown.

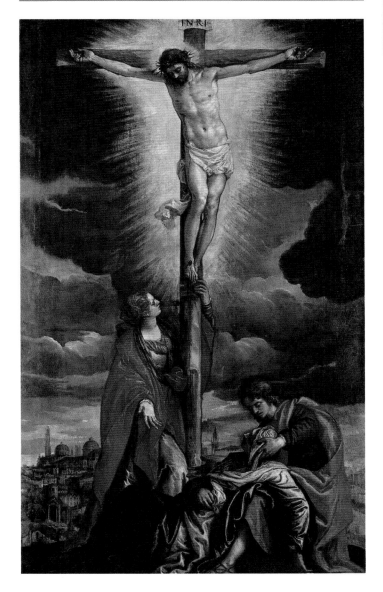

protagonists, in order to depict the subject as a full, historical event, became increasingly common from the thirteenth century. Duccio's *Maestà* panel is probably one of the earliest important compositions of this type to be incorporated into an extended Passion cycle. Such paintings often include, apart from the Virgin, St John, and Mary Magdalene, the Holy Women, Longinus the centurion, soldiers and other anonymous bystanders. The Renaissance, with its preoccupation with historical versimilitude, produced the most accurate archeological accounts of the Crucifixion, and Mantegna's painting of 1459 is probably the most impressive and accomplished of these.

Towards the end of the sixteenth century, and no doubt due to the Council of Trent with its censorship of unverifiable legend, detail, and anecdote, full-scale compositions of the Crucifixion became less common. Compositional economy began to replace the vast canvases filled with spectators,

43

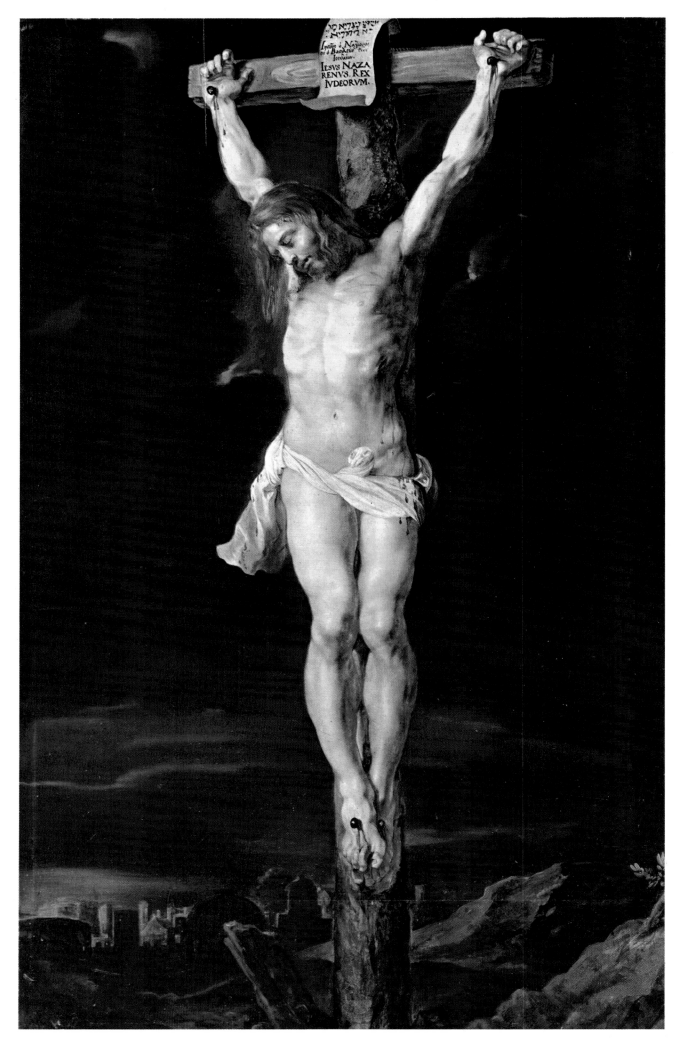

Rubens: *Christ Crucified,*
145 × 92cm, c.1610

soldiers on horses, angels, donors, and anyone else who could conceivably be drafted into the scene. The most reprehensible aspect of these crowded works was the likelihood that they would distract the pious beholder. The Church suspected that devout contemplation was unlikely to be aided by the diversity, animation, and picturesque detail of

Grünewald: *Christ on the Cross with the Three Maries, St John and Longinus,* 73 × 52·5cm, c.1510

This is the earliest and most crowded of Grünewald's four *Crucifixions.* The second, dated 1515, is the central panel of the Isenheim Altarpiece at Colmar and shows St John, the Virgin, Mary Magdalene, and St John the Baptist. The third, known as the *Small Crucifixion,* is dated c.1520, and shows the Virgin, St John, and Mary Magdalene. The last version, of c.1526, is the so-called Tauberbischofsheim Altarpiece at Karlsruhe, where only the figures of the Virgin and St John appear with Christ on the cross. The 1510 composition established the basic elements of the succeeding versions. The transverse section of the cross, which is straight here, becomes increasingly bowed, emphasizing the dead weight of the suspended corpse. Grünewald was greatly influenced by St Bridget's *Revelations* and his paintings reflect their mood of ecstatic and paroxsysmic, visionary mysticism. Certain elements in his *Crucifixions* can be matched directly with her words, such as this description of Christ's feet: 'His feet were curled round the nails as round door hinges towards the other side.'

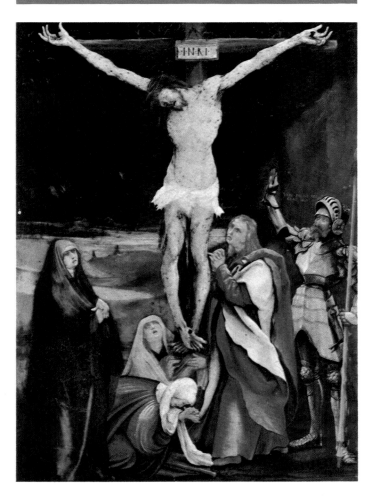

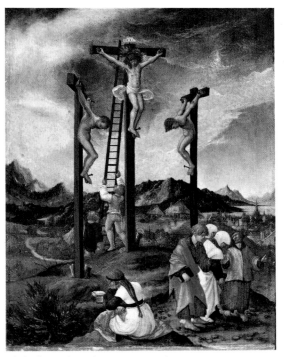

Altdorfer: *Christ between Two Thieves,* 28 × 20cm, 1528

paintings which frequently took on the very physical qualities of a *tableau vivant.*

The disappearance of all but the most basic figures from paintings of the Crucifixion was accompanied by a similar dwindling in the importance given to the landscape setting of the scene. During the seventeenth century many Crucifixions reverted to a simplicity and sparseness reminiscent of the earliest emblematic representations. Although the Virgin, St John, and Mary Magdalene are often depicted, it was the solitary image of Christ on the cross which proliferated during the seventeenth century. This solitary figure, while recapturing something of the austerity of the early images, does so with the aesthetic sophistication, anatomical virtuosity, and humanistic spirit of the time. This results, as it does with the paintings by Velazquez and Rubens of Christ Crucified, in an image of stark human tragedy, infinitely disturbing through its very lack of mystical or historical elaboration.

Whatever the period, the artist who depicted the Crucifixion (and indeed any episode from the Passion) was subject to directives and conditions, traditions and conventions, the vicissitudes of change in dogma, and in ecclesiastical reform and counter-reform. These conditions influenced the approach to the subject and the inclusion or omission of certain iconographical elements. However, as with any subject, it is ultimately the artist's personal vision which combines the given elements into a particular and unique configuration.

Raphael's *Crucifixion* of 1503, charming, serene, delicate, and composed, represents one end of a spectrum of almost infinite gradations. The other extremity is represented by a composition painted within a few years of the Raphael, Grünewald's Basel *Crucifixion* (c.1510), which is feverish, convulsive and saturated in suffering. If the Italians tended to observe Classical monumentality and restraint, and the Germans to emphasize the punatively gruesome, it is, never-

45

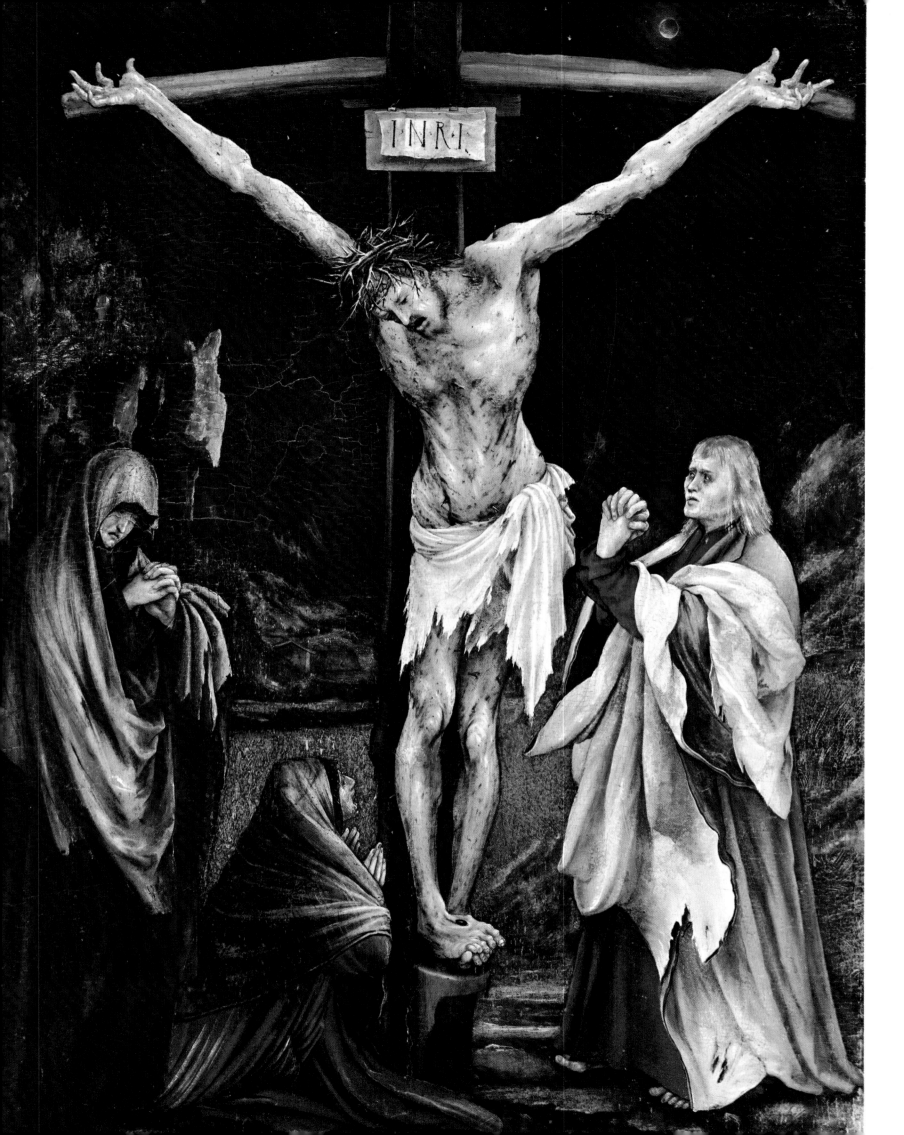

theless, the temperament of the artist which results in a work becoming the epitome of serenity or of suffering. Raphael's *Crucifixion* appears bland and somewhat frivolous when compared to Grünewald's. The difference is between an image which subjects a convention to a supreme degree of technical and compositional perfection and an image which takes the same convention and shakes off its automatic familiarity through an intense, almost hysterical mysticism. If Raphael's *Crucifixion* could easily lend itself to a placid and reassuring contemplation for the devout, that by Grünewald demands a great deal more. Its effect on believer and unbeliever alike is enough to erode the defences of complacency and security.

Grünewald painted four versions of the Crucifixion all of which share the same degree of visionary intensity which transcends the superficially horrific. In his novel *Là-bas* (1891), J. K. Huysmans gives a masterful description of Grünewald's Karlsruhe *Crucifixion*, the essence of which is applicable to all four versions:

This was the Christ of the Poor, a Christ who had become flesh in the likeness of the most wretched of those he had come to redeem, the ill-favoured and the indigent, all those in fact upon whose ugliness or poverty mankind wreaks its cowardly spite. This was also the most human of Christs, a Christ frail of flesh, forsaken by the Father until such time as no further torments were possible . . . Never before had realism attempted such a subject; never before had a painter explored the divine charnel-house so thoroughly, or dipped his brush so brutally in running sores and bleeding wounds. It was outrageous and it was horrifying. Grünewald was the most daring of realists, without a doubt; but as one gazed upon this Redeemer of the doss-house, this God of the morgue, there was wrought a change. Gleams of light filtered from the ulcerous head; a superhuman radiance illuminated the gangrened flesh and the tortured features. This carrion spread-eagled on the cross was the tabernacle of a God; and here, his head adorned with no aureole or nimbus but a tangled crown of thorns beaded with drops of blood, Jesus appeared in his celestial supra-essence, between the Virgin, grief-stricken and blinded with tears, and St. John, whose burning eyes could find no more tears to shed . . . Grünewald was the most daring of idealists . . . from the depths of squalor he had extracted the finest cordial of charity and the bitterest tears of woe. In this picture was revealed the masterpiece and supreme achievement of an art which had been bidden to represent both the invisible and the tangible, to manifest the piteous uncleanness of the body, and to sublimate the infinite distress of the soul.

In illustrating the variations in approach to the essential significance of the Passion nothing could be more explicit than a comparison of Grünewald's *Crucifixion* pictures and what Huysmans refers to as 'the debonair Golgothas adopted by the Church ever since the Renaissance'.

Following the Crucifixion, the next important episode of the Passion is the Descent from the Cross, or Deposition. All four of the Evangelists describe how Christ's body was taken down from the cross and how the wealthy Joseph of Arimathea went to Pilate and begged to have the body. John's Gospel is the only one to mention that Nicodemus assisted Joseph in anointing the body and wrapping it in a

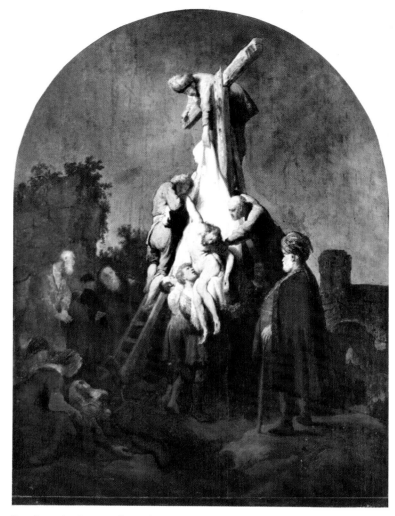

Rembrandt: *Descent from the Cross.* 93 × 68cm. 1633

linen shroud. Paintings of the Deposition invariably show Joseph and Nicodemus engaged in lowering the body from the cross, usually accompanied by the Holy Women who are described as having been present, and by the Virgin and St

Bosch: *Calvary.* 73 × 61cm

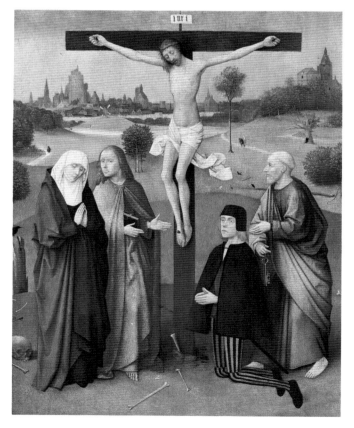

John who are not actually mentioned. Duccio's *Deposition* depicts the most common convention for the scene, with Joseph at the top of a ladder lowering the body into the arms of the Virgin, while John supports the knees and Nicodemus extracts the nail from the feet with a pair of pliers. The majority of pictures of the Deposition show Christ's body supported at several different points so that it maintains a certain graceful control, but Rembrandt's *Descent from the Cross* is unusual in its realistic rendering of the flaccid dead-weight of the corpse.

The central part played by the wealthy Joseph of Arimathea in the Deposition made the subject of particular interest to rich donors. They often appear, in the role of Joseph, dressed in incongruously extravagant garments. This is a feature of van der Weyden's *Deposition* and is even more strikingly apparent in the connected picture the *Entombment* by Quentin Metsys. There was an equal tendency for

donors to have themselves included in paintings of the Lamentation of Christ. They are present in the composition by the Master of the Wolfegg Ledger, and are conspicuous in miniature form in Dürer's *Lamentation*. Although there is no mention of an incident of lamentation in the Gospels, and properly speaking it is not an episode of the Passion cycles,

Van der Weyden: *Descent from the Cross,* 220 × 262cm, and detail, c.1430–40

Van der Weyden's refined spirituality and controlled fervour find their supreme expression in this magnificent Deposition. Against a symbolic gold background, Christ is lowered from the cross supported by Joseph of Arimathea on the left and Nicodemus on the right. The pathos and unrestrained emotion which frequently characterizes this subject is sublimated and absorbed into the formal rhythm of the composition itself. In showing the Virgin in a position which is the almost exact parallel of that of Christ himself, van der Weyden is employing a symbolic device which was common to the Middle Ages and which conveyed the belief that the Virgin experienced the same degree of suffering as her son. This shared suffering is expressed through the similarity of the poses. The raised central section of the painting suggests that it must once have had shutters.

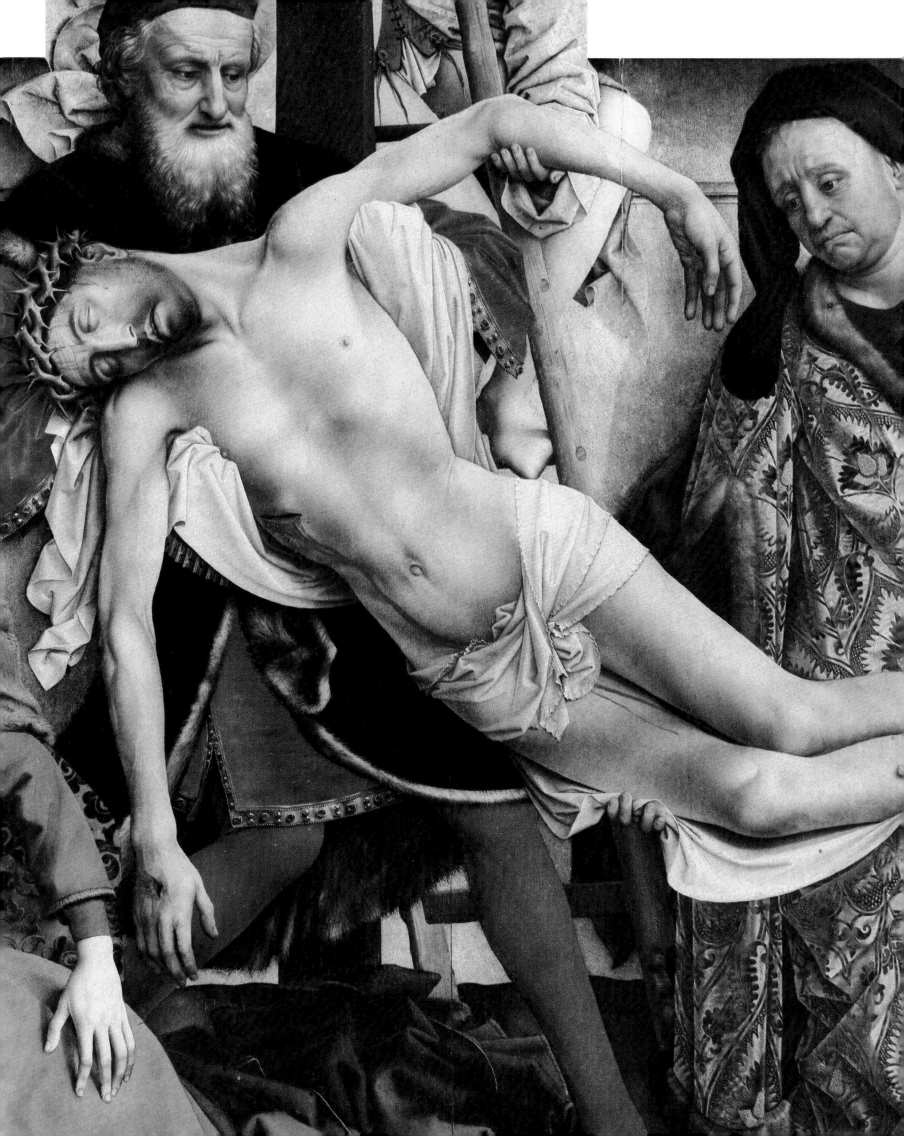

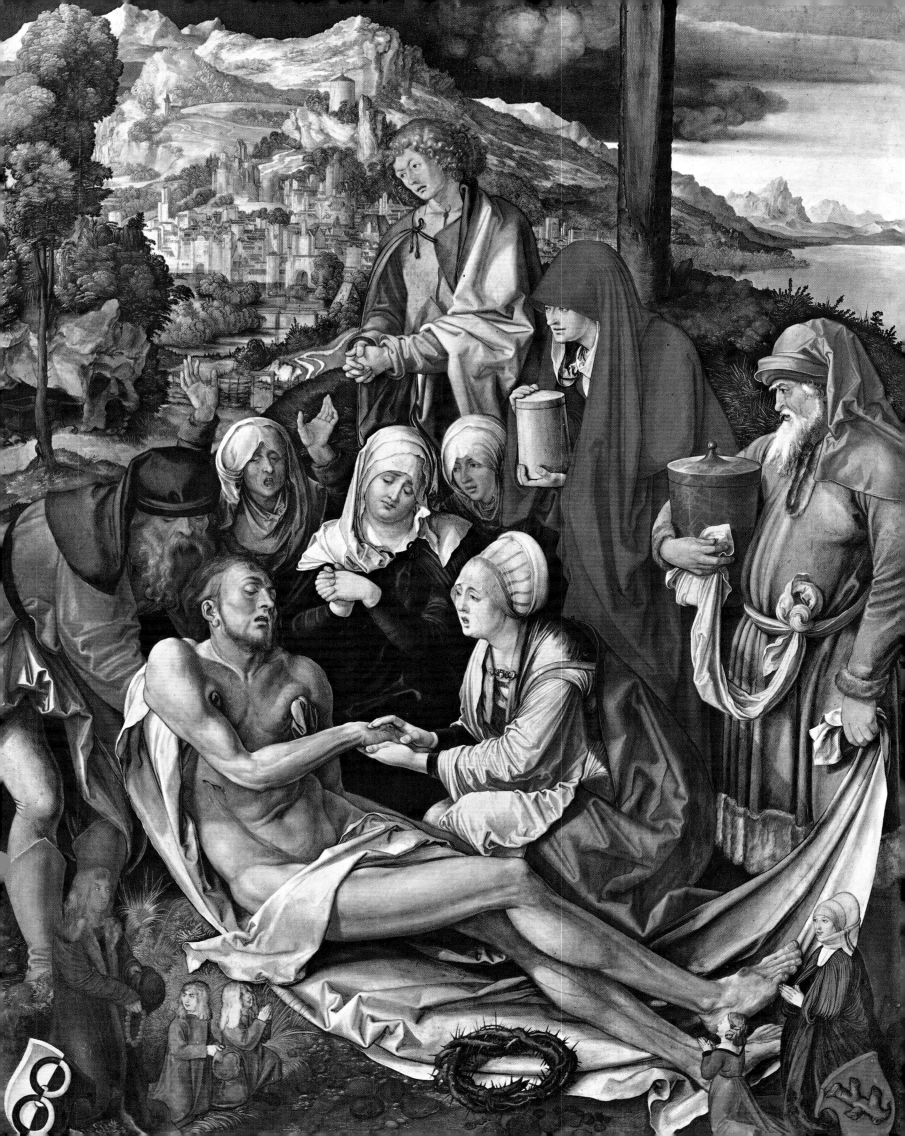

Opposite **Dürer:** *Lamentation over the Dead Christ*, 151 × 121 cm, 1500

This *Lamentation* was painted for the goldsmith Albrecht Glimm and was dedicated to the memory of his first wife Margreth who died in 1500. The painting was intended for the Predigerkirche at Nuremberg. The donor kneels in the left foreground with his two sons, and to the right Margreth kneels with one of her daughters. In keeping with the convention of hierarchy, these figures are considerably smaller than the main figures in the composition. Dürer has composed the nine main figures into a monumental pyramid, the traditional funeral form. Nicodemus prepares to lift Christ's body and Joseph of Arimathea, carrying a jar of herbs and spices for embalming, holds the other end of the shroud. They are about to carry the body to the tomb which is seen, cut into the rock, behind Nicodemus. The figures are grouped at the foot of the cross against an exquisite landscape, with Jerusalem, depicted as a Gothic German city, possibly based on Nuremberg, built on a mountain with a castle at the summit.

Pages 52–3. **School of Avignon:** *Pietà*. 162 × 218 cm, c.1460

The *Pietà* was one of the last important motifs to be added to the imagery of the Passion, and this painting is undoubtedly the most superlative rendition of the subject and the greatest French painting of the fifteenth century. The figures of Christ and the Virgin, surrounded by St John, Mary Magdalene, and an unknown donor, have a strong sculptural bias which reflects the origin of the subject in German wood carvings of the fourteenth century. The sculptural convention, symbolic gold background and stylization of the figures coexist with a startling realism in the depiction of the whip marks on Christ's body. Even these, however, are disposed with an almost abstract uniformity and regularity.

the Lamentation is nevertheless frequently depicted, particularly in Northern art of the fifteenth century. It is usually seen taking place at the foot of the cross and includes the same protagonists as those involved in the Deposition.

Another, similar subject, which like the Lamentation is an artistic convention rather than an actual episode from

Master of the Wolfegg Ledger: *Lamentation*. 131 × 171 cm. second half of the 15th century

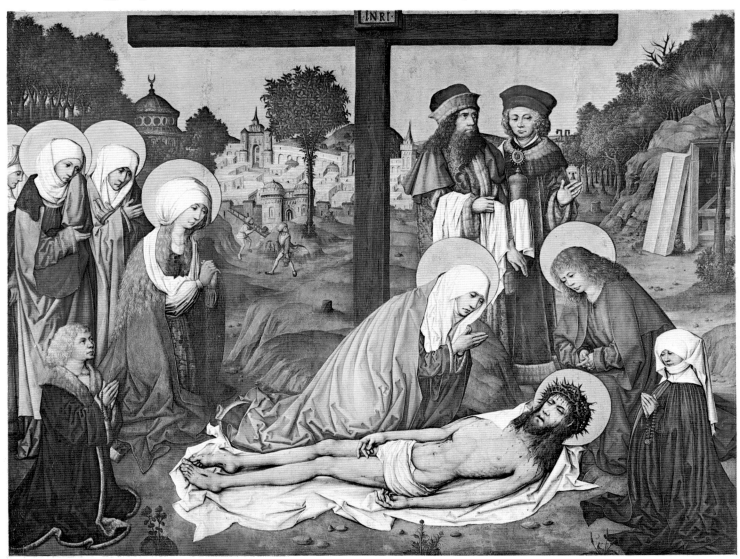

School of Avignon:
Pietà

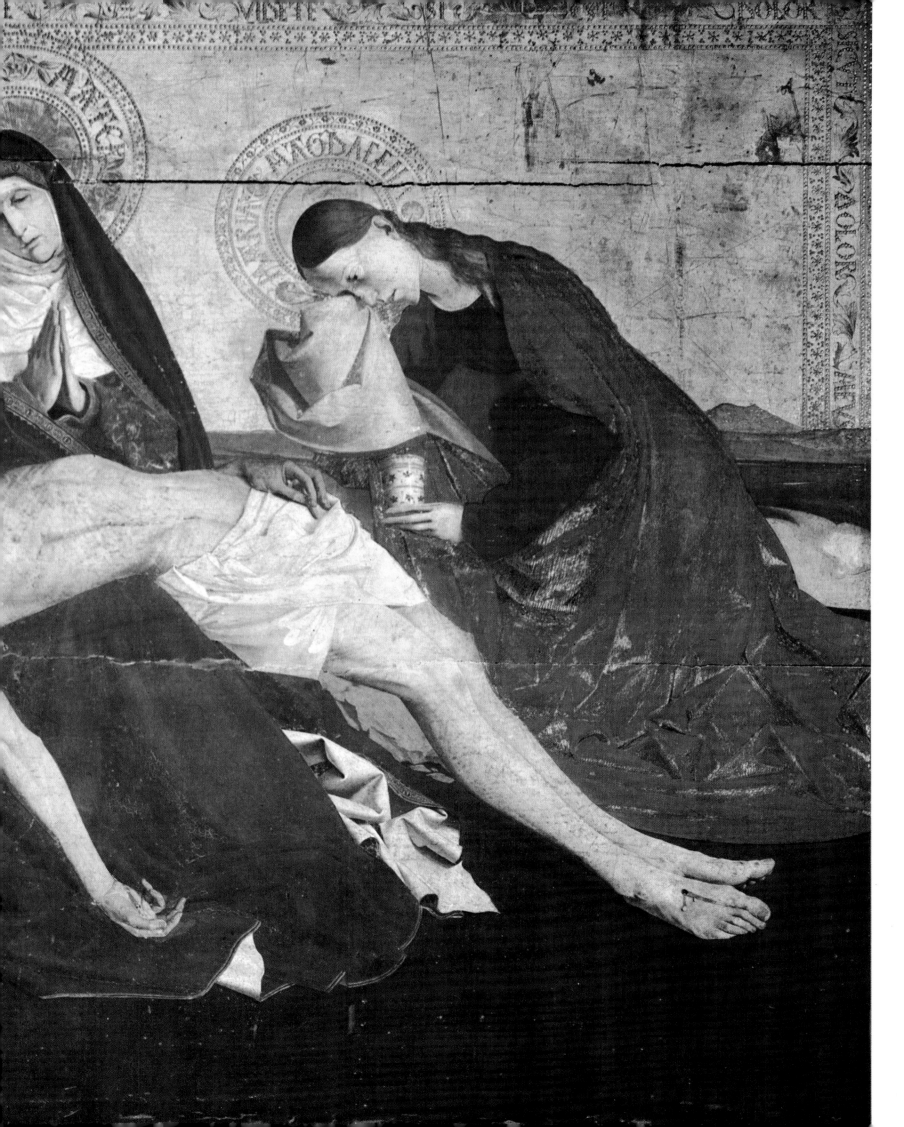

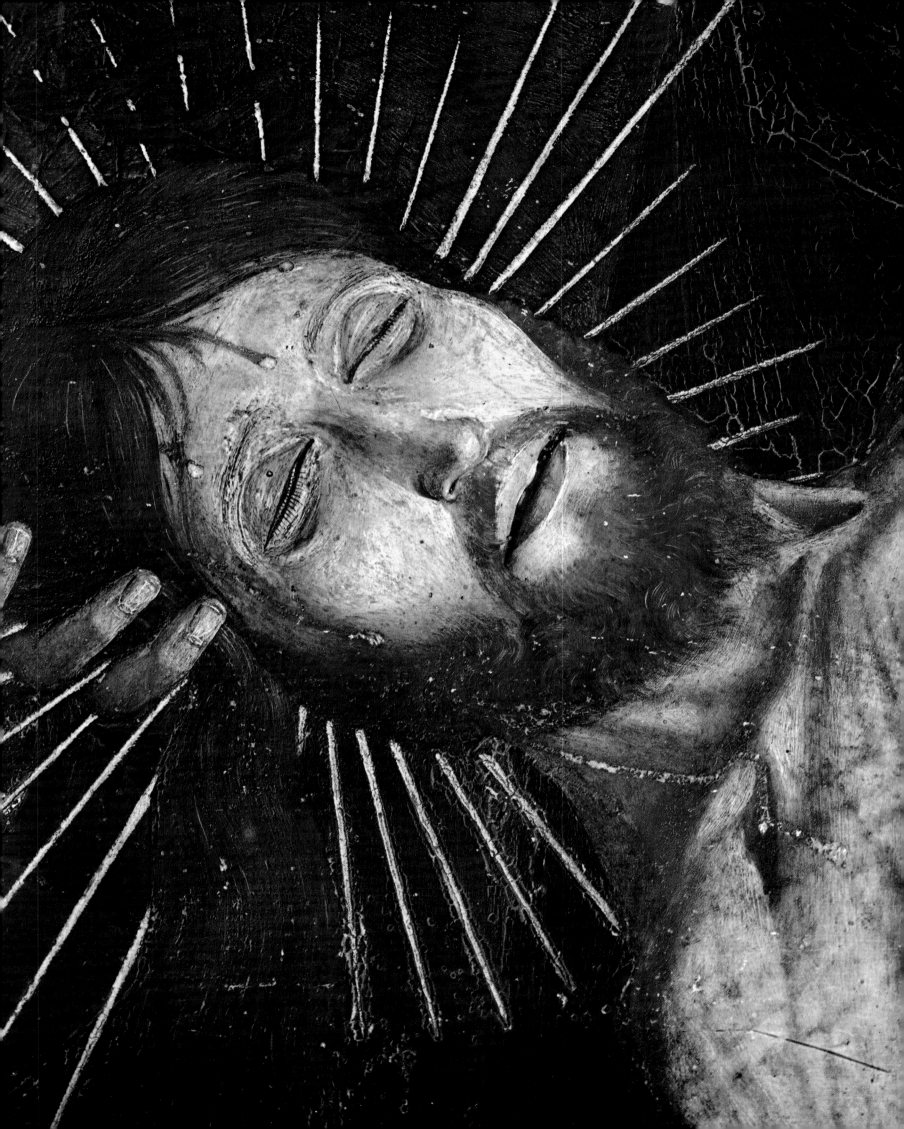

Cranach the Elder: *Pietà*, 54 × 74cm, c.1500

the Passion, is the Pietà. The Pietà is often incorporated into scenes of the Deposition, the Lamentation, or the Entombment. It is essentially the image of the Virgin weeping or mourning over the body of Christ, and as such presents a moving dialogue between life and death. It seems unlikely that the subject appeared any earlier than the thirteenth century. In its characteristic form it shows the dead Christ lying across the Virgin's knees in a type of tragic repetition of the image of the Virgin with the Christ Child on her lap. This connexion was made more explicit in medieval art where the figure of Christ is often much smaller in scale than that of the Virgin. A later example of this device is seen in Giovanni Bellini's *Pietà* of c.1502, where the diminished figure of Christ provides a striking contrast to the corpse of gigantic proportion in Fernando Gallego's *Pietà*.

There are numerous variations on the Pietà image, many of which do not show the figure of Christ on the Virgin's knees. A fairly common variation is the composition showing the dead Christ with the Virgin accompanied by angels, as seen in Andrea del Sarto's painting which manages to avoid the more overt sentimentality of such scenes. Cranach the Elder's *Pietà* is in reality a devotional image of the Man

Andrea del Sarto: *Pietà*, 99 × 120cm, 1525

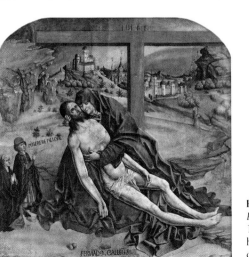

Fernando Gallego: *Pietà*, 169 × 132cm, second half of the 15th century

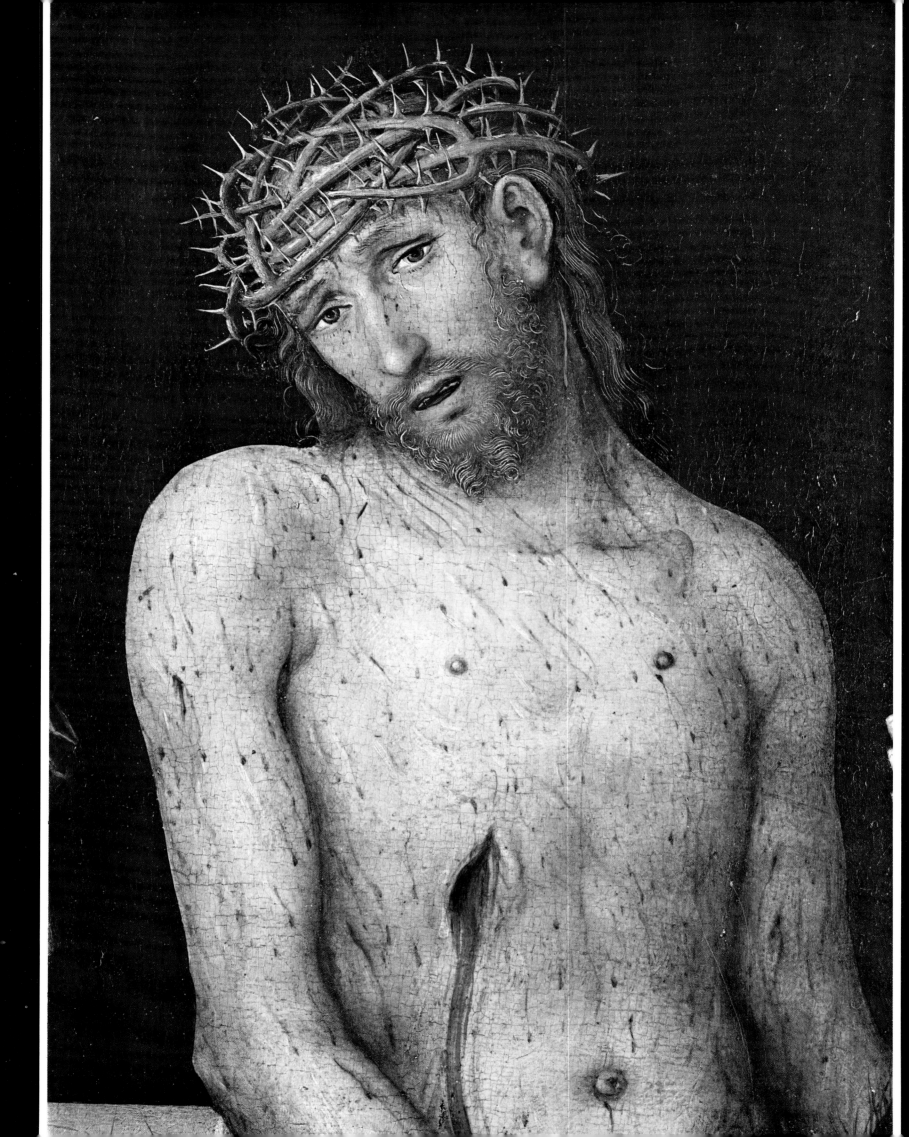

OPPOSITE **Cranach the Elder:**
Pietà (detail)

Crivelli: *Pietà.* 105 × 205cm.
c.1485

Rubens: *Triptych of the Pietà.* central panel 135 × 98cm. side panels 135 × 40cm

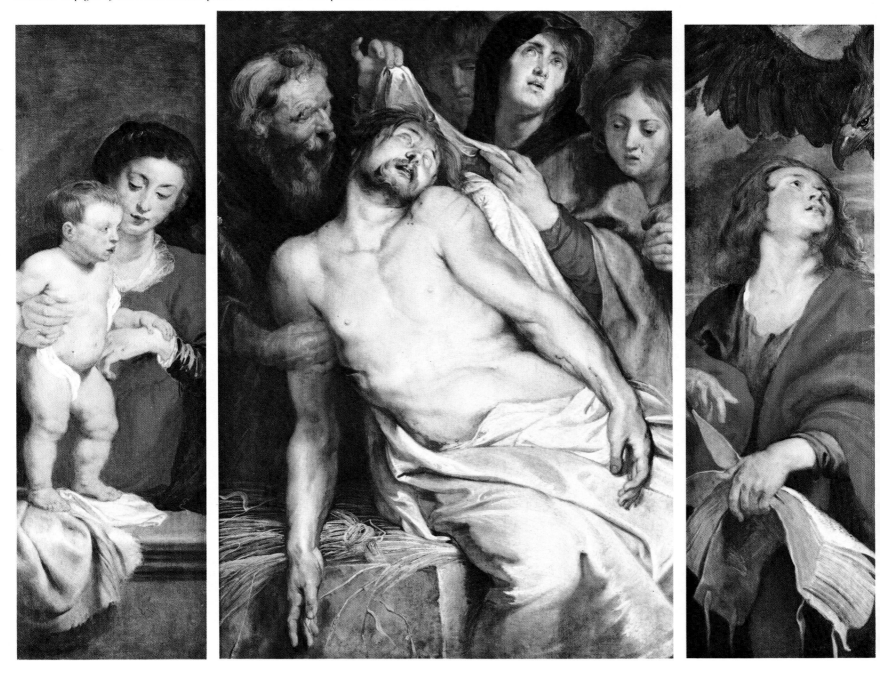

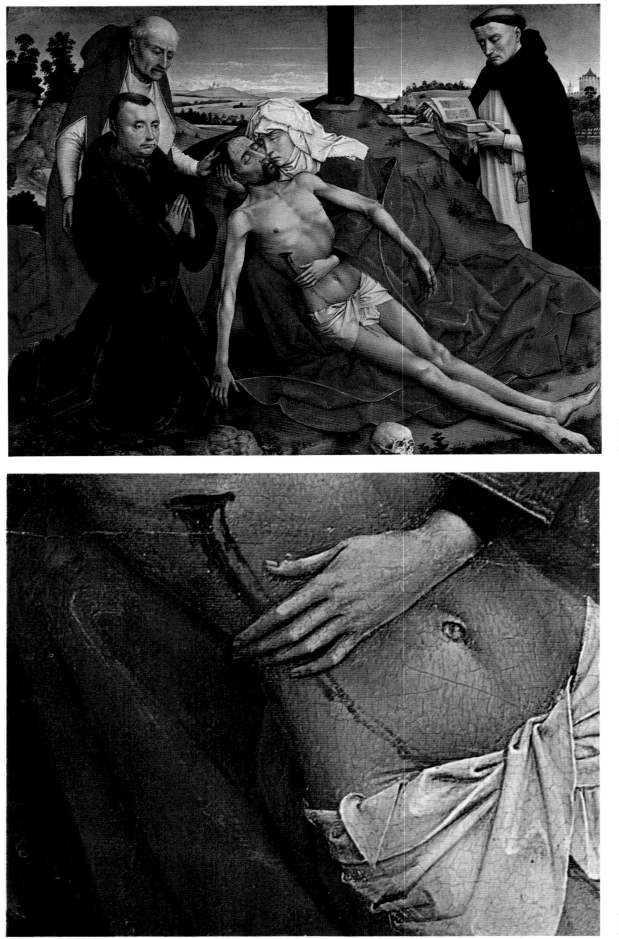

Van der Weyden:
Pietà, 33·5 ×
45cm, c.1460–4

Van der Weyden:
Pietà (detail)

of Sorrows with Christ shown wearing the crown of thorns and carrying the instruments of the Passion.

The Bearing of Christ's Body to the Sepulchre, like the Lamentation and the Pietà, is an artistic amplification of the Gospel accounts rather than a traditional episode of the Passion. Although not often depicted, it seems to occur most frequently in Italian art of the Renaissance, and the composition by Raphael is probably the best known example. This subject shows similarities with the interpretation of the Entombment such as that by Jacopo Bassano, which shows the body of Christ actually being lifted into the sepulchre.

The Entombment is a central episode of the Passion cycle and although it often concludes the series, it is frequently followed by the Resurrection and Apparitions as it is in Duccio's cycle. In more generalized cycles of the Life of Christ where the Resurrection and subsequent episodes are included, the Entombment is a necessary prelude. The

Giovanni Bellini: *Pietà*, 107 × 86cm, c.1470

In cutting his figures off at waist level with the horizontal edge of the sepulchre Bellini emphasizes their strict verticality. This is unusual for the subject which characteristically stresses the stooped form of the Virgin, bowed in grief over the recumbent body of Christ. In presenting his figures half-length, Bellini concentrates attention on the facial expressions which are treated with insight and show a marked sensitivity to the nuances, and the paradoxical beauty, of grief. St John, unable to conceal his distress, turns away from the Virgin's intimate and preoccupied scrutiny of her son's face. Although St John and Christ, with his powerful physique, are clearly idealized, the Virgin is not and her compellingly human countenance increases the pathos of the scene.

Pages 60–1. **Bellini:** *Pietà* (detail)

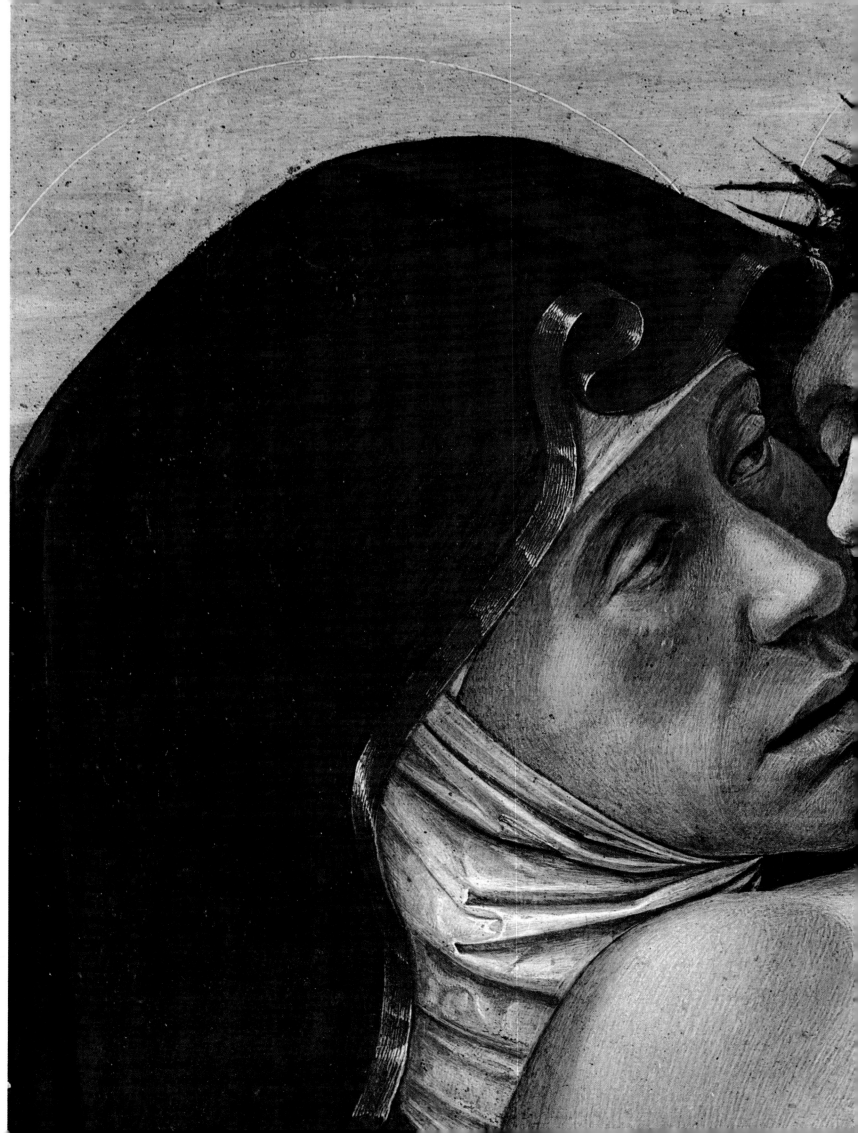

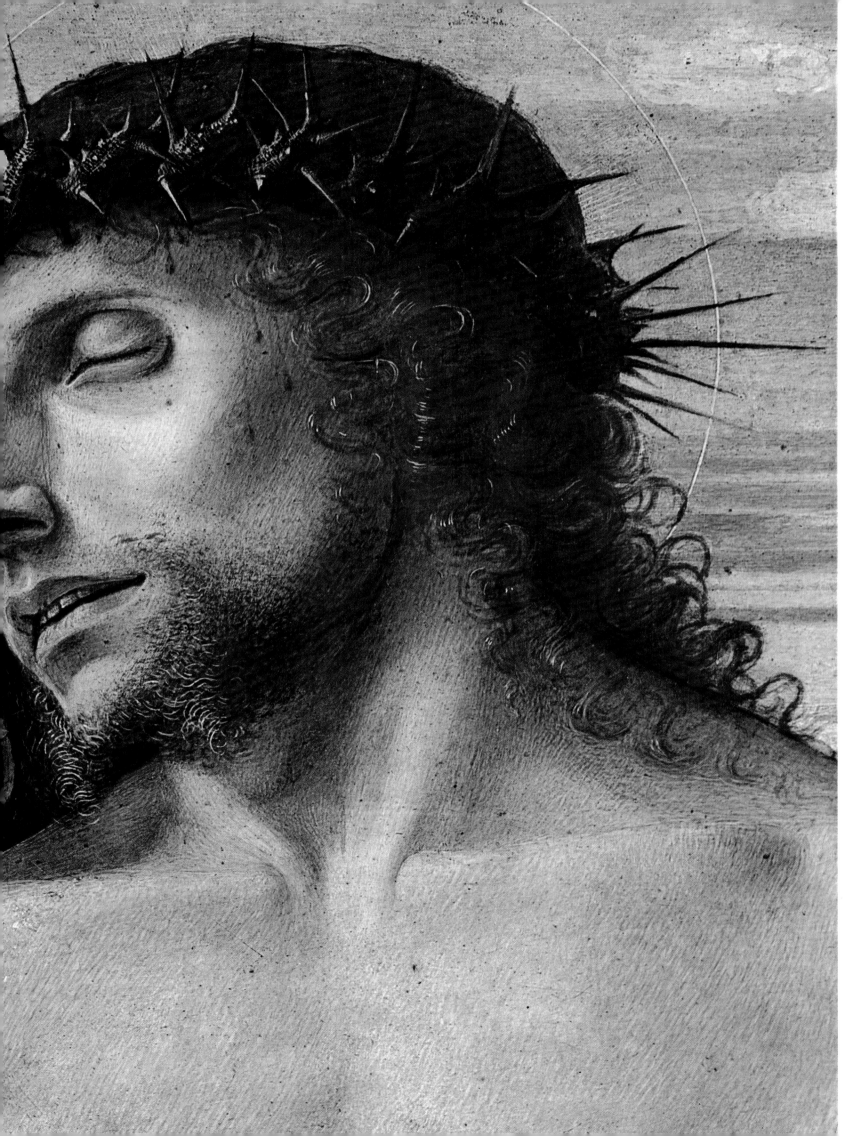

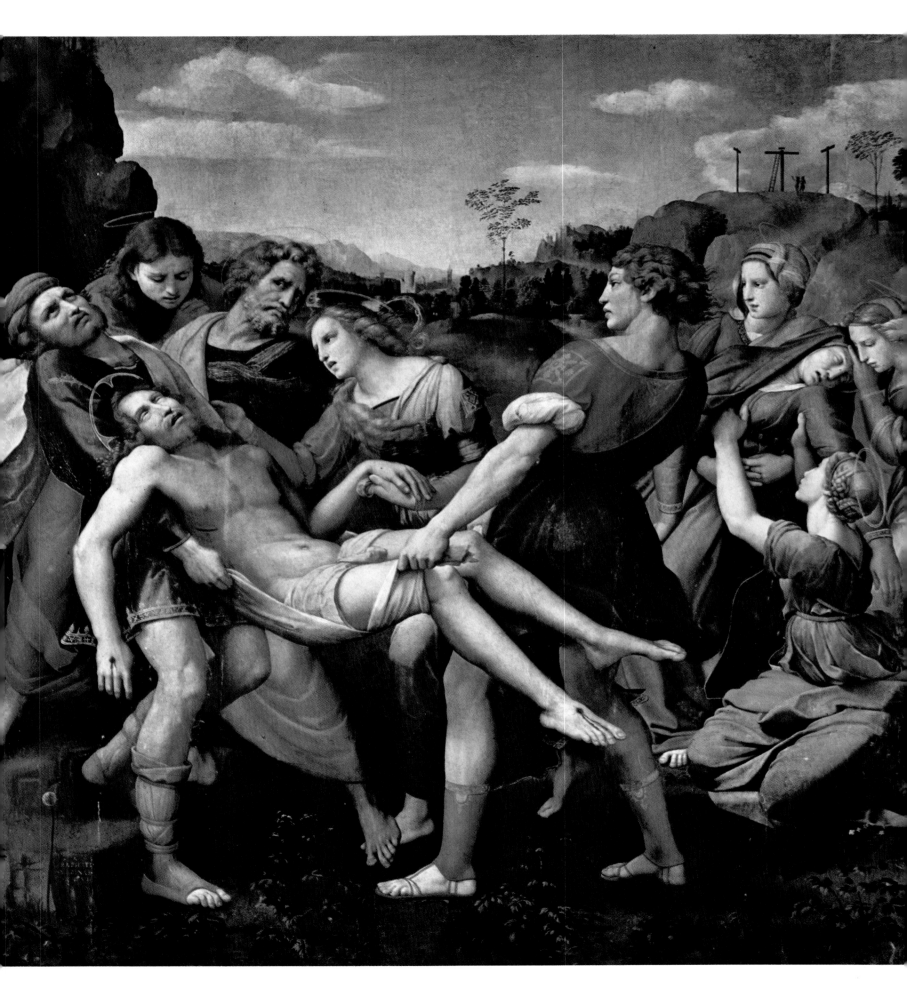

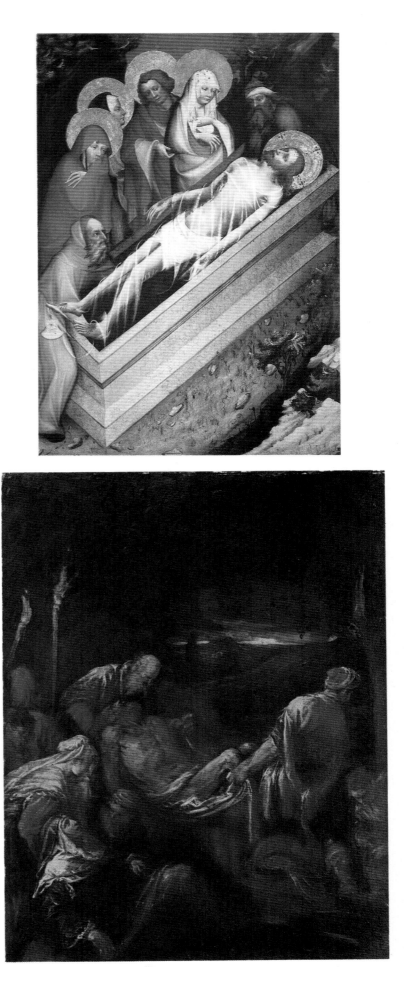

Opposite **Raphael:** *Christ Carried to the Sepulchre,* 184×176cm, 1507

This altarpiece was commissioned by Atalanta Baglioni in memory of his son Grifonetto. The figure of Christ, relaxed, almost as if sleeping, was inspired by an Antique sarcophagus of the 'Burial of Meleager'. This source not only provided a formal motif, in the way that early depictions of the Entombment were often based on Roman military sarcophagi, but also referred to Grifonetto. Meleager is mentioned in the *Iliad* (Book 9) as a hero of the past who was killed after being persuaded to defend his city. The memory of Grifonetto is honoured by this allusion. Raphael's grouping of his figures is classically idealized, and there is an effective physical contrast between Joseph of Arimathea who strains to support the weight of the body, and the younger Nicodemus, who appears to carry the load with little effort. The group is approaching the entry to the tomb, and, as they do so, the Virgin faints and is held up by the Holy Women. This element of pathos is treated with classical restraint, and although the composition attains a rhythmic perfection, it lacks a truly tragic dimension.

Gospels recount the burial of Christ by Joseph of Arimathea. St Matthew states that it took place in a new rock tomb that Joseph had prepared for himself, and St John reports that Nicodemus was also present. The Entombment is occasionally shown from the interior of the tomb itself, and the painting by Altdorfer demonstrates the full dramatic potential of this device.

The Entombment is the last episode in the exclusively human drama of the Passion and concludes the sequence of Christ's physical sufferings. However, there is an additional category of subject which succeeds the apparent finality of the Entombment, reinforces Christ's human physicality, and is concerned with a post-mortem appraisal rather than being related to the action of the narrative. These compositions, such as Carpaccio's *Burial of Christ*, Mantegna's *Dead Christ*, and Holbein the Younger's *Christ in the Tomb*, represent one of the most interesting categories of subject related to the episodes of the Passion.

In extended Passion cycles such as Duccio's, the human grief and tragedy of the Entombment is counteracted by the depiction of the subsequent miraculous events, which affirm Christ's divinity and vindicate the episodes of agony and humiliation. Duccio follows the *Entombment* with the *Descent into Limbo*, and this subject is seen quite frequently in Passion cycles although it seldom appears after the sixteenth century. Christ's descent into Limbo (or Hell) appears as an article in the Apostles' Creed although it has no source in the Gospels and is derived most probably from the apocryphal Gospel of Nicodemus. Limbo or Hell is often shown as a monstrous mouth lined with vicious teeth, and Christ appears in a brilliant white robe, carrying a cross which has been transformed into a spear and pennant. He is seen

RIGHT, ABOVE **Master of Trebon:** *Entombment,* 132×96cm, c.1380

RIGHT, BELOW **Bassano:** *Entombment,* 82×60·5cm, c.1570

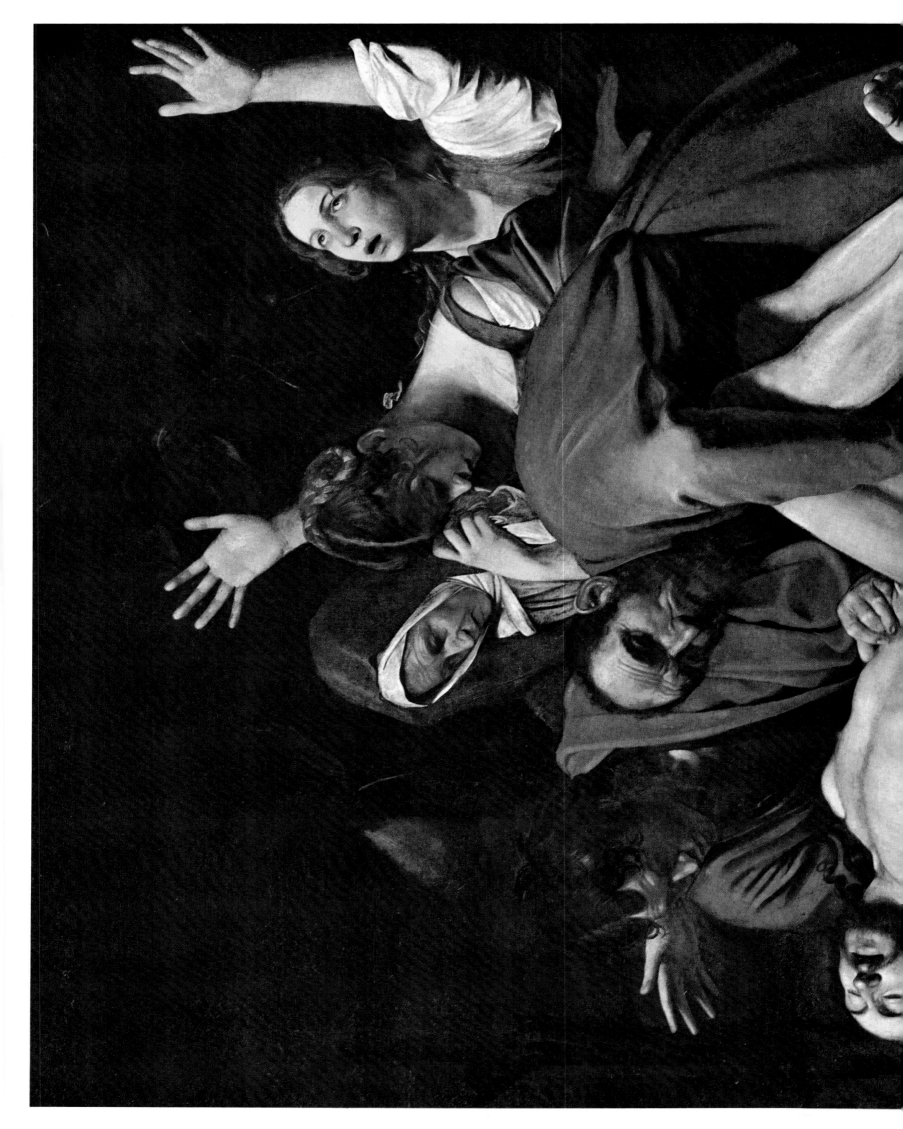

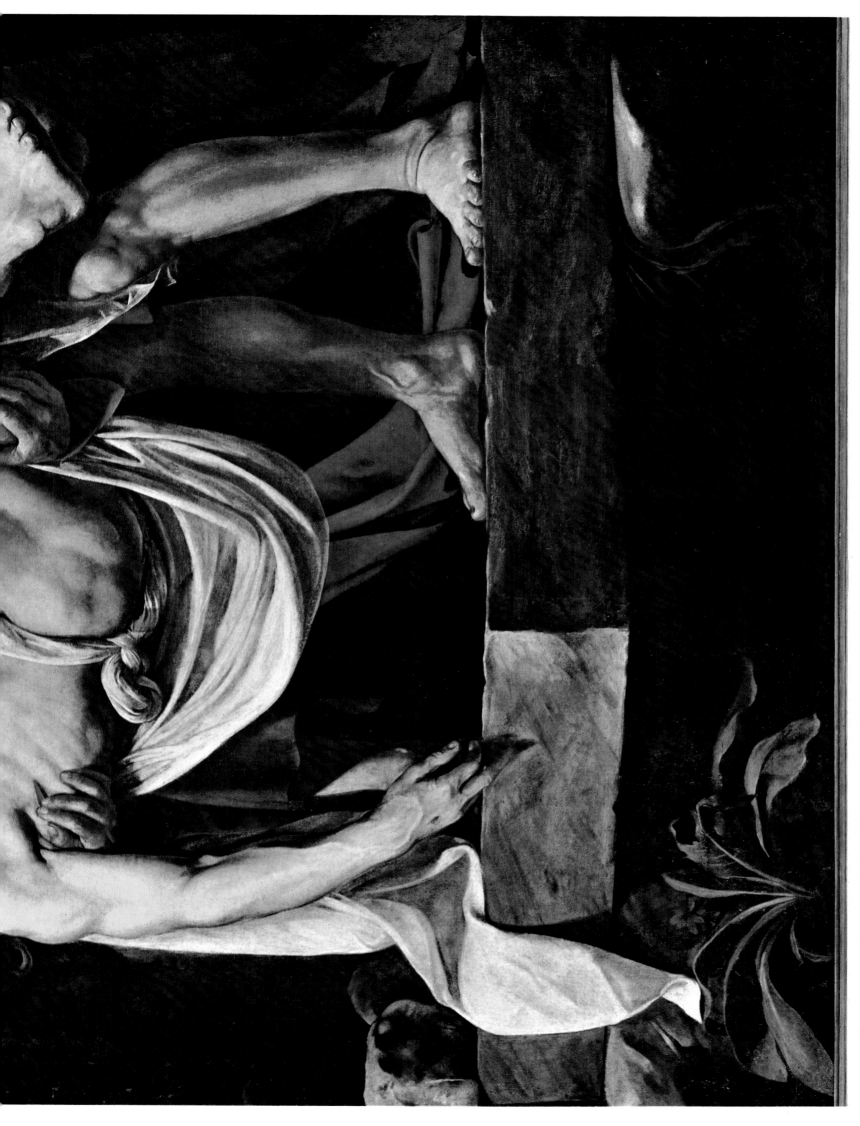

Caravaggio: *Entombment.* 300 × 203 cm. 1604

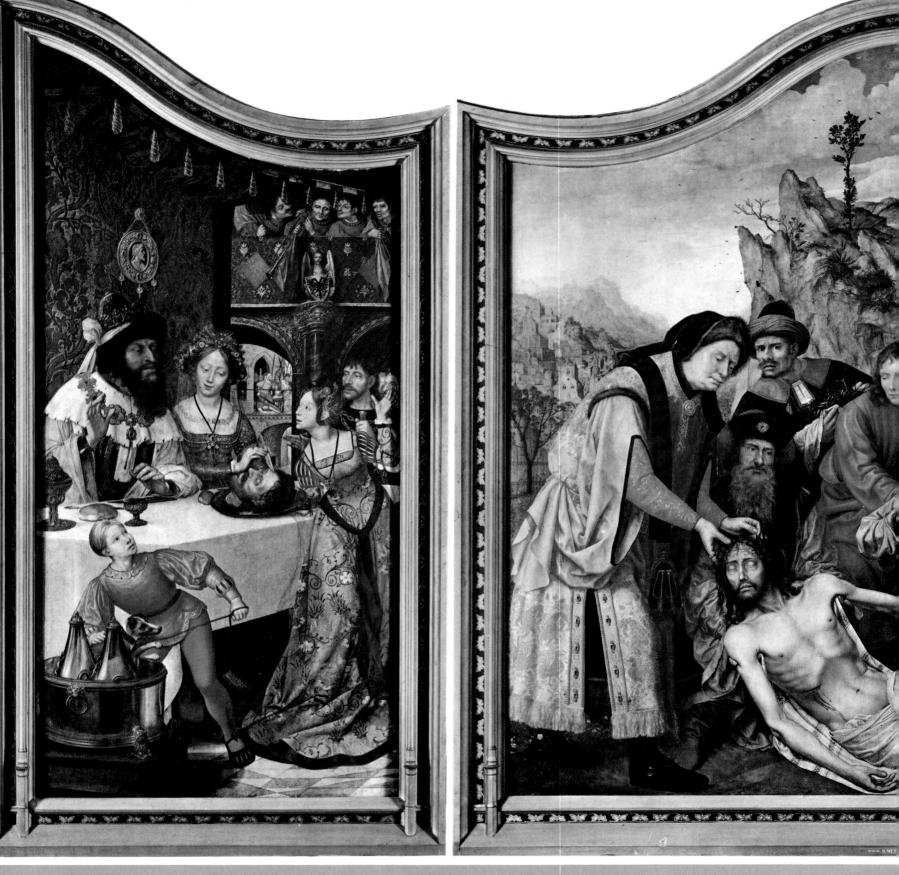

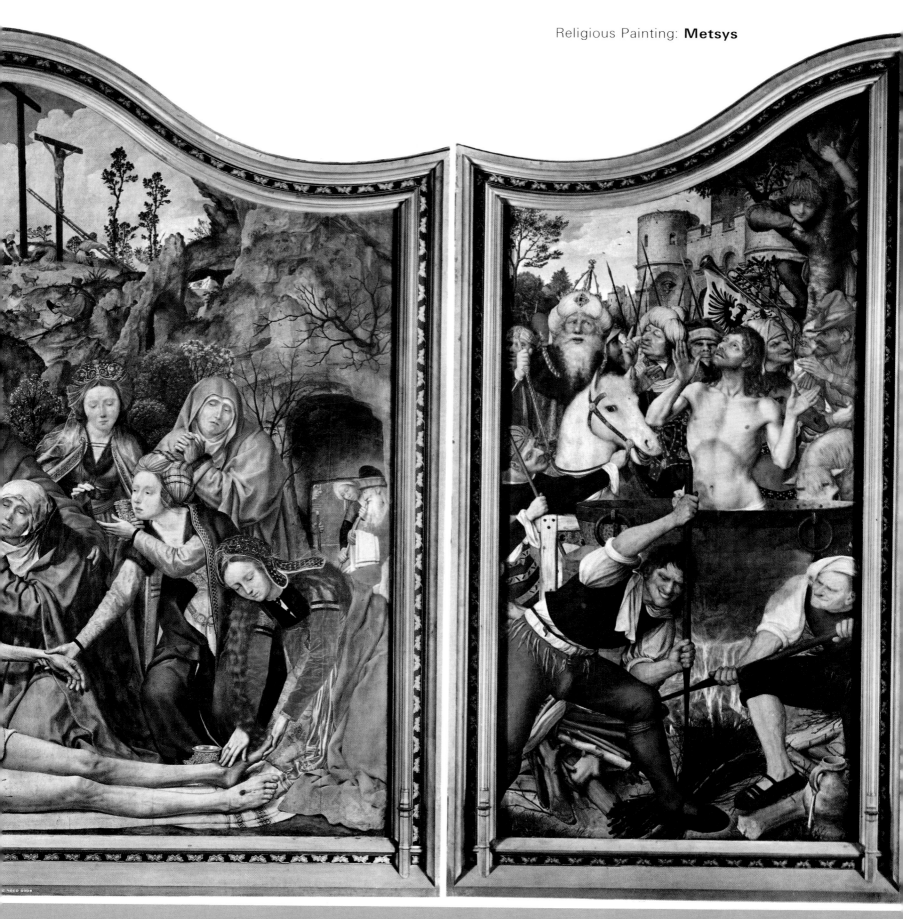

Metsys: *Burial of Christ*, central panel: 260 × 273cm, side panels: 260 × 120cm, 1511

This triptych was commissioned in 1508 by the Carpenter's Guild of Antwerp. Overwhelming both in scale and dramatic intensity, Metsys' masterpiece shows Christ as the ultimate victim, reduced almost to the level of a specimen on a dissecting table. Joseph of Arimathea holds Christ's head upright and delicately lifts one of the flaps of skin torn from the scalp by the crown of thorns. His heavy gold ring and richly brocaded sleeve are set in poignant contrast with the mutilated head. One of the Holy Women grasps Christ's hand, another wipes the blood from his feet, while the Virgin, supported by St John, is clearly beyond adding her own ministrations to the over-attended body. The side panels are *Salome at Herod's Banquet*, on the left, and the apocryphal subject *St John's Ordeal by Boiling Oil*, on the right.

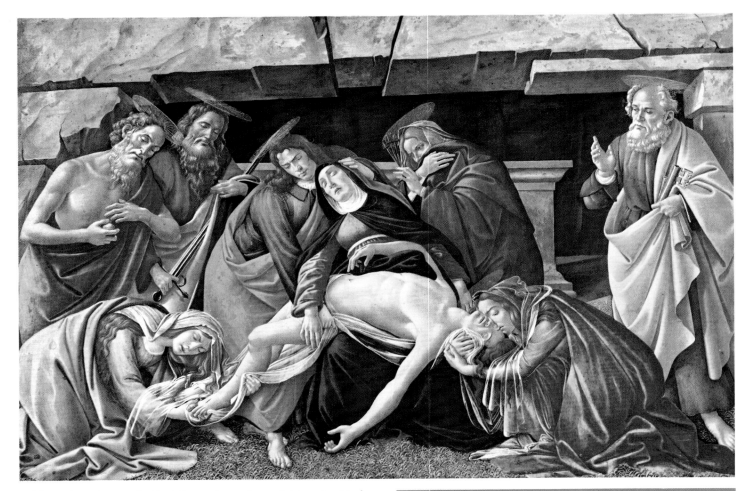

liberating the souls that have been languishing in Limbo since the creation of Adam, and paintings such as Bermejo's, show the souls of Adam and Eve, Noah, Abraham, Isaac, and others, gratefully escaping the torments of devils.

The Resurrection, although a fundamental doctrine in Christianity, is not actually described by the Gospels, and is not usually incorporated into the Passion cycle before the

Botticelli: *Pietà*, 110 × 207cm, 1500

In this painting, executed for the church of San Paolini, St Paul's presence is easily explained, as is that of St Peter although the inclusion of St Jerome is comparatively arbitrary. The Pietà group of the Virgin with the young, and beardless, Christ supported on her knees is the central motif but the setting, at the mouth of the sepulchre, also puts the painting into the category of an Entombment. Rather frenetic and heavily orchestrated, this *Pietà* differs considerably from the serene arabesques and rhythmic elegance of Botticelli's mythological compositions. Nevertheless, his particular quality of sensuality is still discernible, notably in the Magdalene embracing the head of the dead Christ. Towards the end of the fifteenth century, Florence underwent a moral and spiritual upheaval, and the Dominican preacher Savonarola inspired the populace to outbreaks of ascetically-motivated arson. Bonfires were built and paintings, extravagant garments, and other 'vanities', were burnt. Botticelli's brother, Simone, was a supporter of Savanarola, and, although it cannot be proven that Botticelli himself shared his fervour, speculation still exists about the possible influence of Savonarola on his later, more sombre works such as this *Pietà*.

Fra Angelico: *Entombment*, 37 × 45·5cm, c.1440

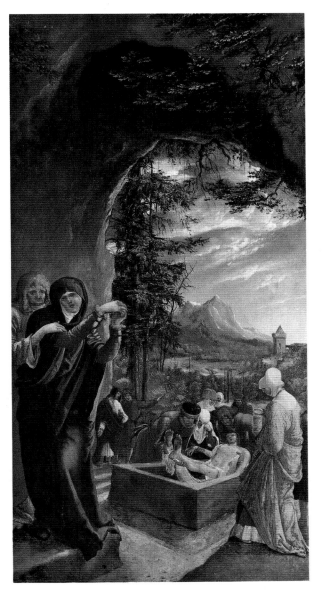

Above **Altdorfer**: *Entombment*, 70·5 × 37·5cm, 1518

As in so many of Altdorfer's compositions, the figures in this painting are a supplement to the romantic landscape. The subject is located in the interior of the tomb, a vast cavern with vegetation covering the walls and roof. Through the mouth of the tomb the landscape is seen bathed in the sulphurous blue light of an Alpine storm. Altdorfer visited the Alps in 1511, and their romantic grandeur greatly influenced his work. The exaggerated gesture and expression of the Virgin are characteristic of Altdorfer, who reinforced the emotional intensity of his paintings with colour and light.

Right **Carpaccio**: *Burial of Christ*, 145 × 185cm, and details, c.1515

Although the body of Christ is clearly a study made from life, this composition differs from the straightforward anatomical studies of the dead Christ. Carpaccio shows him in a bizarre landscape that contains allegorical references to the *Entombment*. On the left, Nicodemus and Joseph of Arimathea open up the tomb, and to the right are the Virgin, St John and Mary Magdalene. Behind Christ an ancient hermit leans against a tree, and above the rock tombs in the middle distance is a figure playing a pipe. On the ground are skeletons and corpses in various stages of decay. They may be the dead who were said to have risen from their graves on the evening of the Crucifixion.

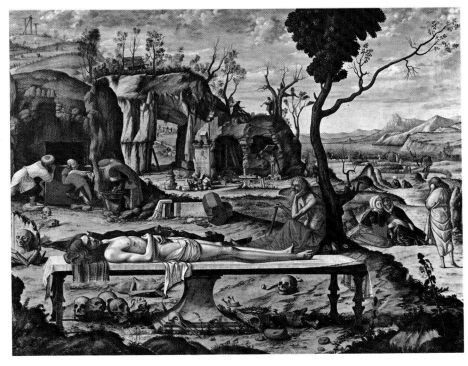

Mantegna: *Dead Christ*, 81 × 68cm, and detail, c.1470

This painting, a brilliant virtuoso exercise in foreshortening, shows Mantegna's preoccupation with resolving problems of perspective. Although predominantly objective in approach, realism is united with a marked idealization of the body with its robust physique and air of peaceful repose. The face, tinged with the bluish lividity of death, has been shaved for burial, and a jar of anointing oil stands at the head of the bier. Only the nail marks and the marginal presence of the grieving Virgin and St John, who provide a striking atmosphere of pathos, indicate that this bravura piece is anything more than an anonymous mortuary study.

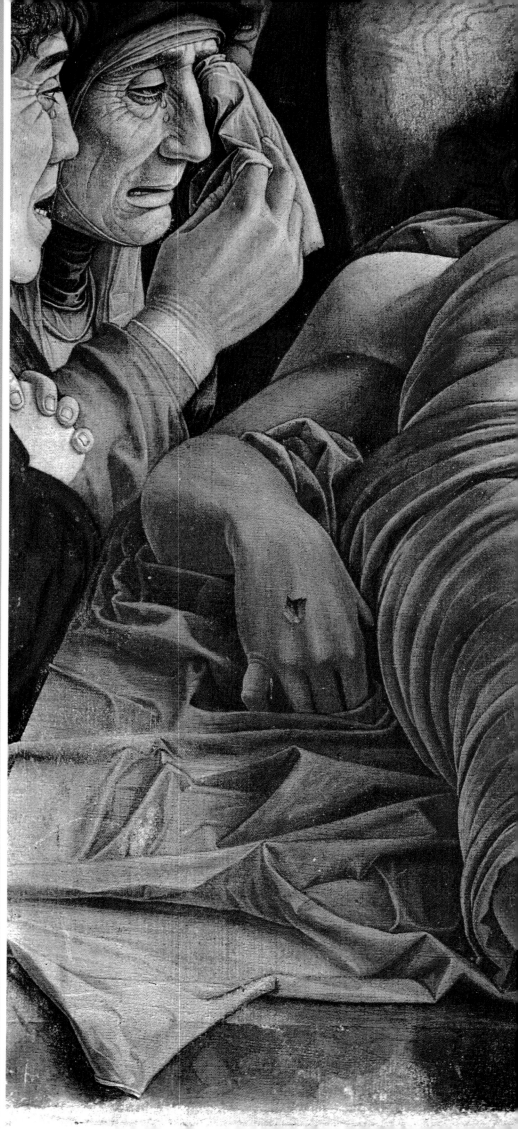

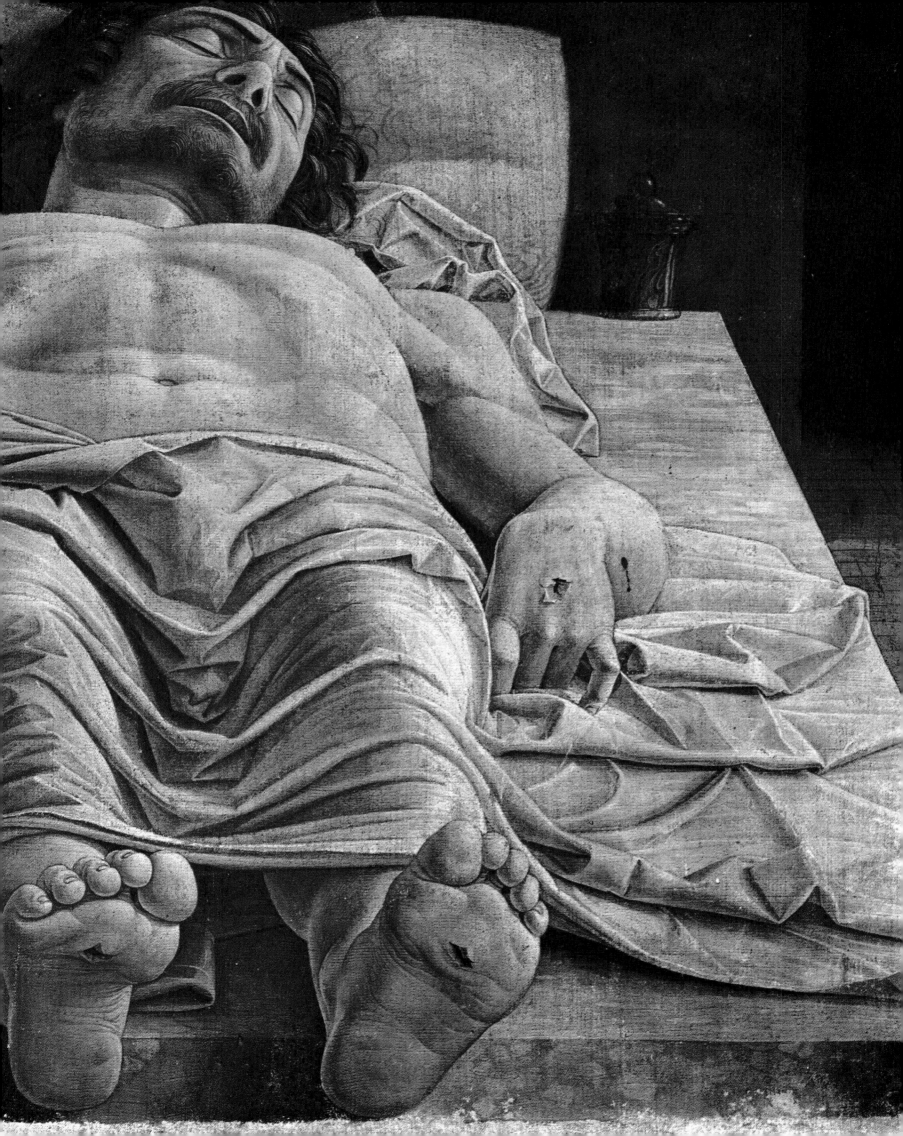

Master of St Veronica: *Man of Pity*, 41 × 24cm, early 15th century

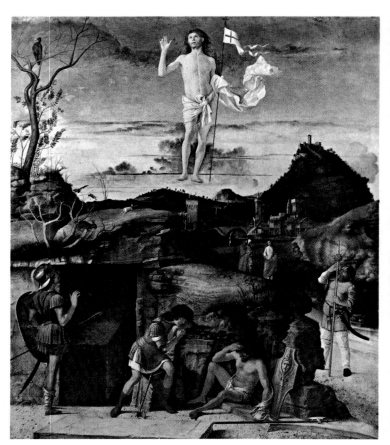

Giovanni Bellini: *Resurrection*, 148 × 128cm, 1475–9

Pleydenwurff: *Resurrection*, 177 × 112cm, c.1460

late thirteenth century. It tends to appear more frequently as an independent subject, and although early examples show Christ virtually climbing out of the tomb, a convention was soon established that showed him airborne, carrying the spear and pennant, and with the guards thrown into disarray. The painting by Sodoma and the more idiosyncratic version by El Greco adhere to the general convention, but Northern art never adopted the hovering figure and, almost without exception, continued to show Christ stepping out of the tomb.

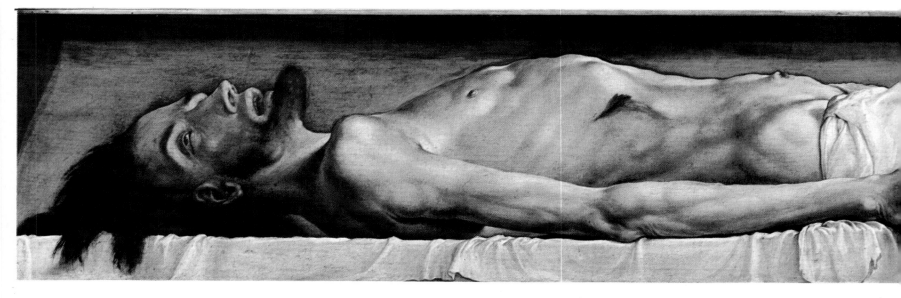

Duccio's cycle, in common with most others before the later fourteenth century omits the scene of the Resurrection, and, in showing the succeeding episodes described in the Gospels, assumes a requisite amount of faith to make the idea of the Resurrection implicit. In Duccio's altarpiece the *Descent into Limbo* appears after the *Three Maries at the Sepulchre*, a subject based on a combination of the Gospel accounts describing Christ's disappearance from the tomb. Mary

Holbein the Younger: *Christ in the Tomb*, 30·5 × 200cm, 1521

The very particular format of this composition indicates that it was painted as a predella for an altarpiece, which cannot now be traced. The impact of this stunning but harrowing work, is increased by the *trompe l'oeil* effect, which gives the impression of a cross section of the tomb. Holbein made a study for this work from nature, rendering the rigidity and contortion of rigor mortis with a scrupulous, scientific exactitude. In Mantegna's *Dead Christ*, the disturbing elements of the subject are reduced by the physical and spiritual idealization of Christ and by the presence of the mourners who add a narrative and emotional dimension. Holbein's painting lacks any such qualities, and the image makes no reference beyond the purely human and existential. Its stark air of finality greatly impressed Dostoievsky who observed that the painting could 'rob many a man of his faith'. A friend of the humanist Erasmus, and illustrator of Luther's Bible, Holbein sums up much of the spirit of the German Reformation.

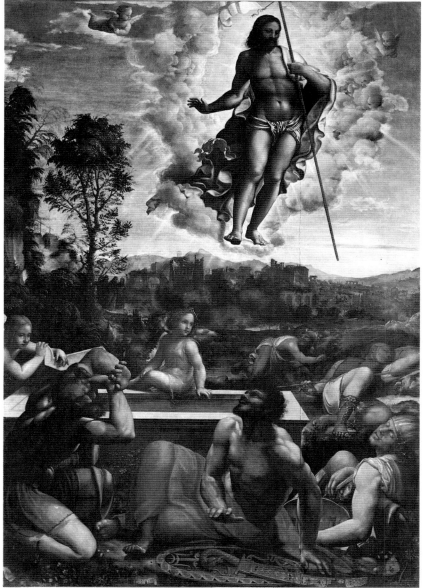

Sodoma: *Resurrection*, 261 × 178cm, 1535

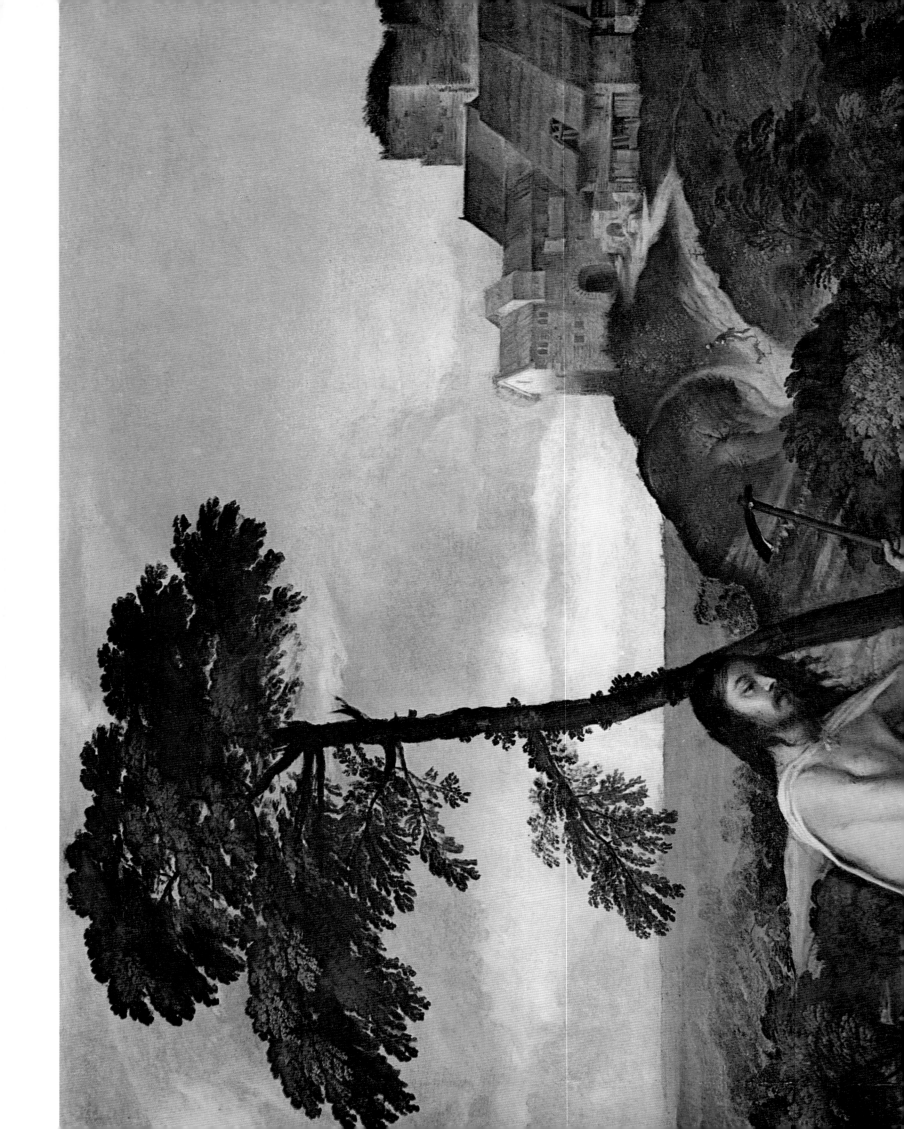

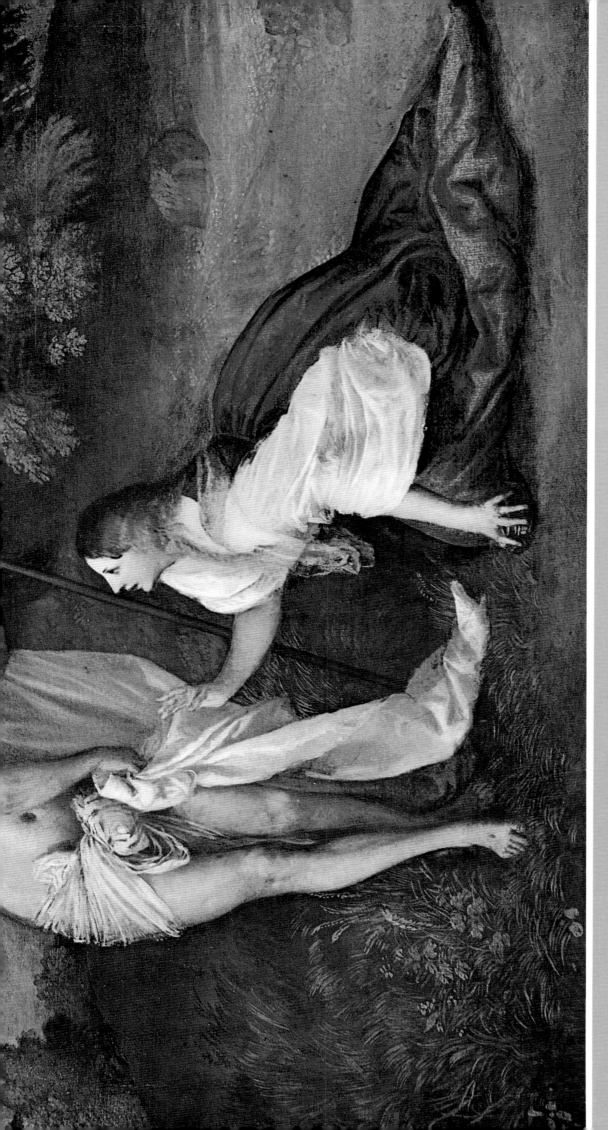

Titian: *Noli me Tangere*, 109 × 91cm, c.1510

St John reports that after his and St Peter's departure Mary Magdalene is left alone weeping at the sepulchre. She sees Christ but thinks that he is the gardener. A literal interpretation of this episode explains why many representations of the subject show Christ dressed as a gardener, usually wearing a broad-brimmed hat and carrying a spade. This element of iconography was presumably introduced early on in order to give a positive identity to the subject. Titian avoids the more absurd forms of identification and shows Christ carrying a relatively unobtrusive hoe. Mary Magdalene, realizing that this is no gardener, but Christ risen from the dead, moves forward enthusiastically to touch him and confirm that he is really there. Christ draws back, speaking the words reported by St John, 'Noli me tangere' (Touch me not). Titian has set the subject in a serene pastoral landscape, and unlike most representations of the scene, he does not show the open tomb.

Caravaggio: *Supper at Emmaus*, 139 × 195cm, c.1598

Caravaggio's realistic and restrained composition restores this subject to the simplicity of its earlier twelfth and thirteenth century interpretation. From the fifteenth century the subject was particularly popular in Venice, where it was commonly depicted as an extravagant display of gourmandise. Caravaggio's *Supper* is suitably frugal: a basket of fruit, a cooked fowl, and the bread which Christ is in the act of blessing. Having met Christ on the road to Emmaus, but not having recognized him, the disciples are shown at the moment of their sudden recognition, prompted by the blessing of the bread. To the right of Christ, St Peter, wearing a cockleshell, the traditional emblem of the pilgrim, flings his arms out in amazement. The younger disciple, Cleopas, clutches the arms of his chair and starts forward as if transfixed. Christ's luminous, and somewhat epicene, countenance imparts a spirituality to the scene and provides the perfect foil to the rustic disciples with their ingenuous reactions of astonishment.

Magdalene, in the company of Mary the mother of James the Less, and Salome known as Mary, are usually shown discovering that the large stone which sealed the tomb has been rolled away.

Duccio follows this episode with Christ appearing to Mary Magdalene, a subject which is also referred to as Noli Me Tangere after Christ's words to Magdalene, 'Touch me not', which are quoted in John's Gospel. Duccio closes his cycle with *Christ at Emmaus*. There are two distinct subjects relating to Christ's appearance at Emmaus. The less common is the Journey to Emmaus where Christ meets the disciples journeying to Emmaus on the day of the Resurrection, but is not recognized by them. It is this interpretation, based on Luke's account, and a brief mention by Mark, that appears in Duccio's cycle. More commonly represented is the Supper at Emmaus, also described by Luke. The last apparition of Christ, recorded by John, took place eight days after the Resurrection and involved Christ's appearance to Thomas. The Incredulity of Thomas is the final and very emphatic reference to Christ's physical existence, showing Thomas

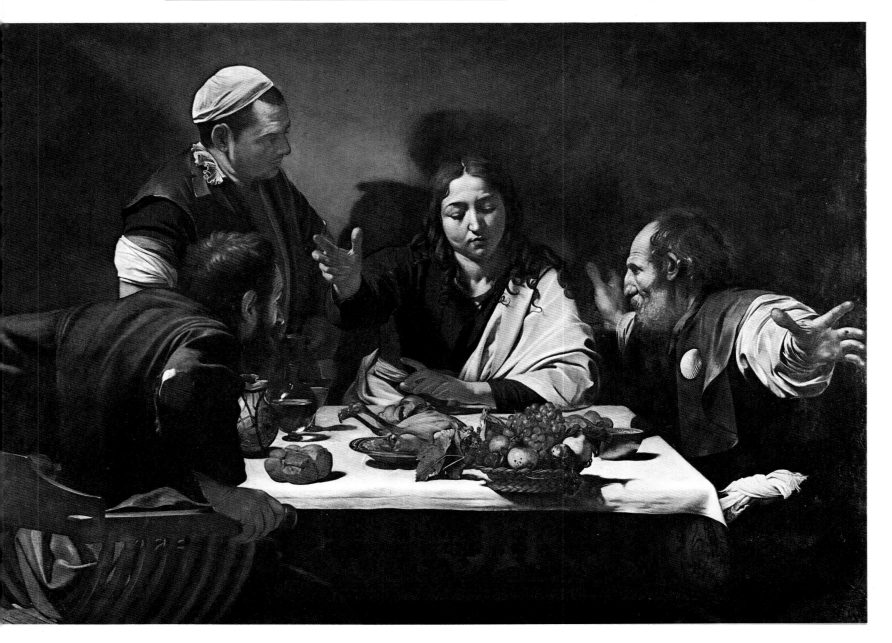

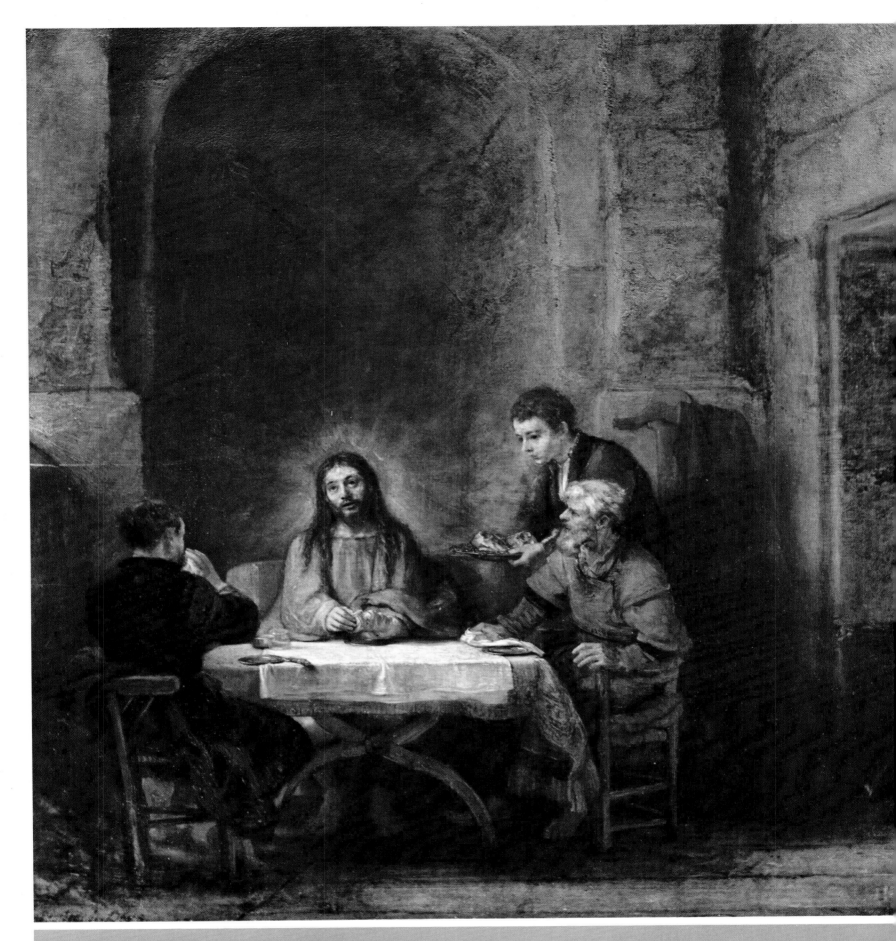

Rembrandt: *The Pilgrims at Emmaus*, 68 × 65cm, 1648

Before Rembrandt religious subjects rarely appeared in the art of the seventeenth century in Protestant Holland. In this small canvas, even more simple than Caravaggio's although much less prosaic, Rembrandt has imbued the scene with a rich spirituality. Christ is seated in a dark alcove and the surrounding gloom is illuminated by a pale light which emanates from his beatific countenance. He is in the act of breaking the bread, and in recognizing him the disciples are shown reacting with more subdued gestures of astonishment than those in Caravaggio's painting.

LEFT **Cima da Conegliano**: *Incredulity of St Thomas*, 215 × 151cm, 1502

RIGHT **Mazzolino**: *Incredulity of St Thomas*, 29 × 17cm, c.1510

thrusting his hand into the wound in Christ's side in order to verify that this divinity, risen from the dead, was indeed the same as the man who had been tortured and crucified.

The Ascension is not actually described by the Gospels but art developed a type of amplified version of the Resurrection to record Christ's final physical disappearance from Earth. Although the Ascension is not an episode of the Passion it is the culminating event in the Life of Christ and the final miraculous justification for the suffering and anguish of the Passion.

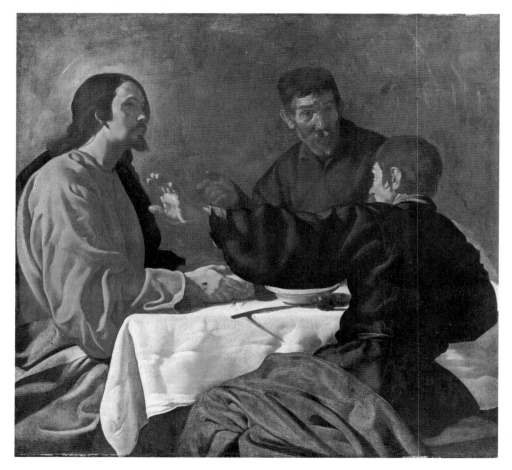

Velazquez: *Supper at Emmaus*, 123 × 133cm

Correggio: *Ascension*, 1520–4

The Ascension is the last miraculous episode succeeding the events of the Passion. Unlike the Resurrection, the subject gives no references to Christ's death, and rather than the earthly element, the open tomb, being the focus of the subject, attention is directed at the celestial. The Ascension was usually conceived as a primarily decorative subject and is often seen in the cupola of a church. It allowed a dramatic and illusion-istic approach and appears most frequently in the sixteenth and seventeenth centuries. Correggio's *Ascension* translates the supernatural into an illusion-istic reality, with aerial perspective and extreme fore-shortening. Christ is seen disappearing upwards into a Heaven filled with voluminous clouds and athletic nudes, and the whole composition has a somewhat burlesque quality which seems far removed from any real religious sentiment. The ecstacies of Counter Reformation Baroque, are here anticipated by Correggio.

List of Illustrations

Bibliography

JAMESON, MRS: *The History of Our Lord*, 1890, vol 2

FERGUSON, GEORGE: *Signs and Symbols in Christian Art*, 1961

WATTS, ALAN: *Myth and Ritual in Christianity*, 1959

MEISS, MILLARD: *Painting in Florence and Siena after the Black Death*, 1964

SCHILLER, GERTRUD: *Iconography of Christian Art*, vol. 2 (The Passion of Jesus Christ), 1972

COPE, GILBERT: *Symbolism in the Bible and the Church*, 1959